Legion of Honor

Selected Works

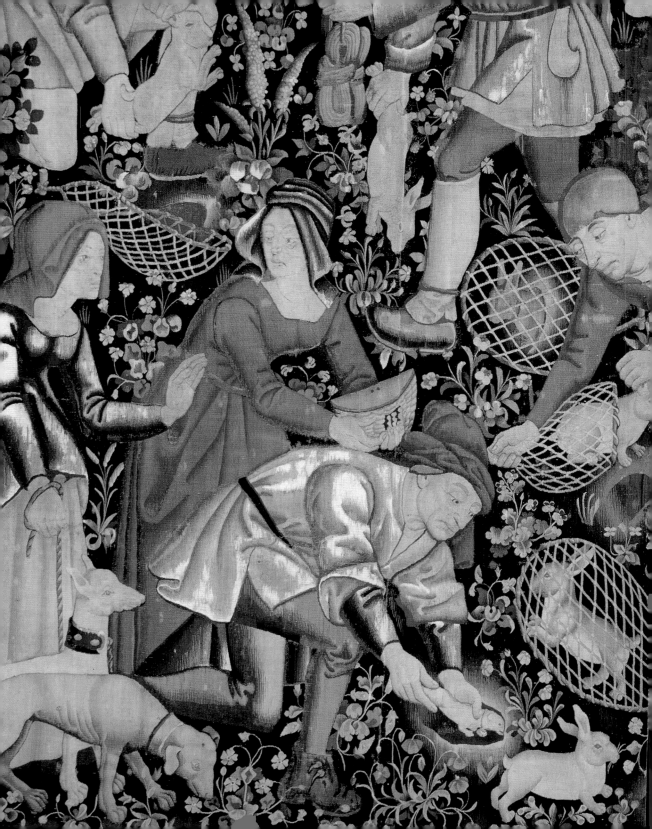

Legion of Honor

Selected Works

Renée Dreyfus

Fine Arts Museums of San Francisco

SCALA

Contents

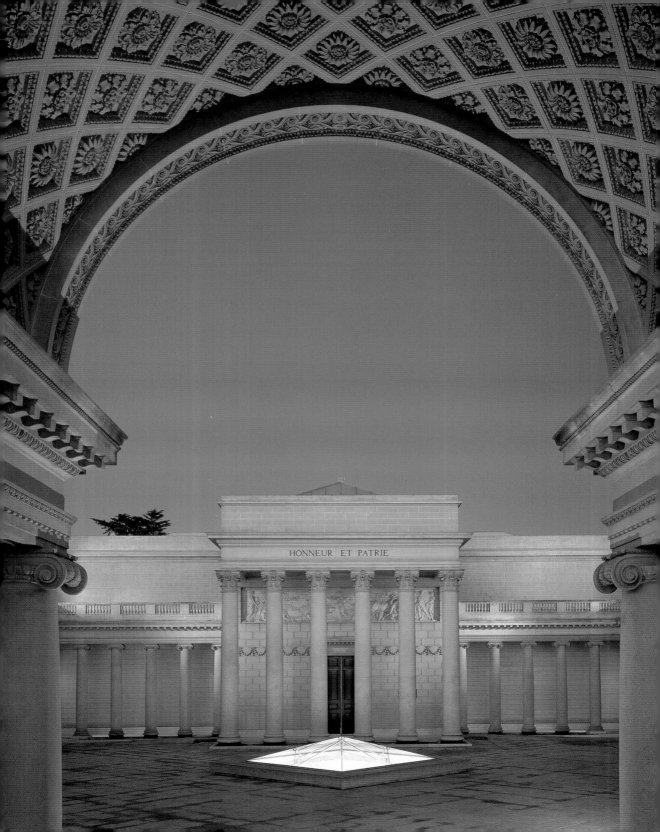

Foreword

We are delighted to publish this catalogue featuring more than 100 masterworks selected from the Legion of Honor's renowned collection. This collection has grown significantly since the museum opened in 1924 in a beautiful Beaux-Arts building located in Lincoln Park, overlooking the Pacific Ocean, the Golden Gate Bridge, and all of San Francisco. The museum's holdings now include European paintings, sculpture and decorative arts from the Middle Ages to the 20th century, textiles, works of art on paper spanning all periods, and antiquities from some of the world's great civilizations. Throughout its long history, the Legion of Honor has remained an important center for the arts, as was the wish of its founder, Alma de Bretteville Spreckels. Her generous contributions have left an impressive museum that maintains a vital presence in the art world.

We thank Renée Dreyfus, Curator in Charge of Ancient Art and Interpretation, for the preparation of this publication, and Associate Curator Louise Chu for her assistance throughout the project. Substantial material and careful review in their subject areas came from curatorial colleagues: Lynn Orr, Martin Chapman, and Marion Stewart in European Art; Robert Flynn Johnson, Karin Breuer, and Louise Siddons at the Achenbach Foundation for Graphic Arts; and Diane Mott and Jill D'Alessandro in Textiles. Managing Editor Elisa Urbanelli, and Ann Karlstrom, Director of Publications and Graphic Design, worked with the designer in New York, Pooja Bakri, and our copublisher, Scala Publishers (Oliver Craske, Editorial Director, and Tim Clarke, Production Director), to produce this book of selected works from the Fine Arts Museums' collections at the Legion of Honor.

It is our hope that this publication will provide more information on these significant works of art and inspire our visitors to return time and time again to enjoy them in their magnificent setting.

John E. Buchanan, Jr.
Director of Museums

The Court of Honor
Photograph by Richard Barnes

The Museum above the Golden Gate

The California Palace of the Legion of Honor is perched on a remote headland overlooking the spot where the Pacific Ocean flows into San Francisco Bay—one of the most beautiful locations in San Francisco. This unique art museum, the gift of Alma de Bretteville Spreckels, is made even more dramatic by its imposing French neoclassical architecture.

According to legend, Alma Spreckels's friend Loïe Fuller, the flamboyant dancer of belle époque Paris, selected the site. However, it is more likely that architect George Applegarth chose the location. Alma and her husband, San Francisco sugar magnate Adolph B. Spreckels, toured the French pavilion at San Francisco's Panama-Pacific International Exposition in 1915. They were not only impressed with an exhibition of sculpture by Auguste Rodin but also delighted by the pavilion itself. It was a replica of the Palais de la Légion d'Honneur in Paris, completed in 1788 as the Hôtel de Salm, which was occupied for only a year by its owner, a German prince whose fortunes fell with the French Revolution. Madame de Staël owned it briefly; then in 1804 Napoleon took it over as the home of the Légion d'Honneur, the order he created to reward civil and military merit. Alma was so impressed by the building at the exposition that she offered to construct a permanent version of it as an art museum for San Francisco.

At the close of the exposition, the French government granted permission to build the replica. However, World War I delayed this ambitious project until 1921, when Marshal Foch of France marked the groundbreaking by planting a Monterey cypress near the site. Under the direction of Applegarth, the museum was finished in 1924 and opened its doors on Armistice Day of that year. Following the wishes of the donors to "honor the dead while serving the living," the city of San Francisco accepted it as a museum of fine arts dedicated to the memory of the 3,600 California men lost on the battlefields of France during the war. The focus for this new museum was determined at its founding by Alma Spreckels's admiration for French and other European art.

Applegarth's design for the building was a three-quarter-scale adaptation incorporating the most advanced ideas in museum construction. The 21-inch-thick walls were built with hollow tiles to keep temperatures stable. The heating system design eliminated radiators and filtered the air with atomizers to remove dust. Seven thousand cubic yards of concrete and a million pounds of reinforcing bar were required for this innovative structure. By the 1980s, however, the landmark needed structural improvement. Beginning in March of 1992, the

Legion underwent a major renovation—seismic strengthening, a building systems upgrade, restoration of historic architectural features, and an underground expansion of 35,000 square feet. On November 11, 1995—its 71st anniversary—the building reopened. The architects who accomplished this challenging feat, which neither altered the historic facade nor affected the environmental integrity of the site, were Edward Larrabee Barnes and Mark Cavagnero.

Considering this museum as her mission in life, Alma Spreckels not only provided the building but also formed the museum's early collection. She gave a group of sculptures by Rodin, to whom she had been introduced by Loïe Fuller and whose works she began to acquire at the Panama-Pacific Exposition. In 1917, shortly before his death, the artist invited his new patron to his studio to select works. This early contact with Rodin allowed Alma to purchase casts made during his lifetime. Through a period of nearly 35 years she assembled a collection of Rodin's work that is one of the finest outside of France, including an early cast of *The Thinker* acquired from the artist in 1915. She eventually donated more than 80 works in plaster, terracotta, marble, and bronze covering all periods of Rodin's career.

Among other important works Alma gave to her museum were French furniture, silver, and ceramics; antiquities; and a large group of objects associated with the art of dance. The influence of her friendship with Loïe Fuller and her connections with French artistic circles

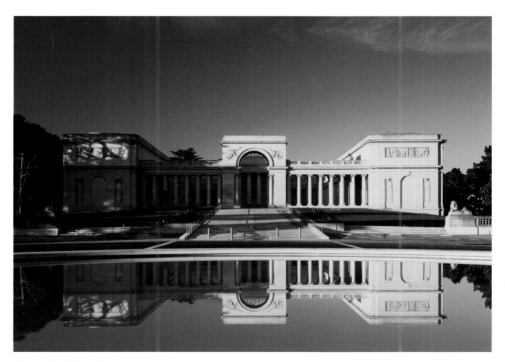

Photograph by Richard Barnes

led her to collect dance-related sculpture and drawings, as well as costume and set designs for the opera and the ballet. The works she purchased were exceptional and included stage designs for Diaghilev's Ballets Russe by Russian avant-garde artists such as Natalia Gontcharova, Mikhail Larionov, and Léon Bakst. Her donation of this material supplemented by several gifts from other sources created at the Legion a theater and dance collection that ranks among the best in the country.

Other important art patrons responded to Alma's encouragement to enrich her galleries. Among the first was Archer M. Huntington, who presented the Legion with a collection of 18th-century French paintings, sculpture, tapestries, porcelain, and furniture given in memory of his father, Collis P. Huntington, one of the "Big Four" who built the transcontinental railroad. Much of this collection had been put together by Archer's mother, the socialite Arabella Huntington, who created one of the first serious collections of French decorative arts in America.

The acquisition of the Mildred Anna Williams Collection in 1940, along with the establishment of an endowment fund to ensure its growth, set the Legion on its path to become the art museum it is today. Mildred Anna and Henry K. S. Williams were friends of Alma and agreed to deed to the museum the contents of their house in Paris. Just in time to catch the last steamer to leave Marseilles before World War II began, 70 paintings, tapestries, and pieces of fine furniture were packed up and sent to California. Henry Williams continued his support even after the death of his wife. The prudent use of his endowment fund enabled the Legion to augment the original gift, adding European paintings from the 16th to the 19th centuries, among them works by Lucas Cranach, Jean-Baptiste Oudry, Elisabeth Louise Vigée Le Brun, Edgar Degas, Pierre-Auguste Renoir, and Edouard Manet.

Albert Campbell Hooper strengthened the areas of Dutch and Flemish painting of the 17th century and English painting of the 18th century with the gift of about 400 works. The collection of Hélène Irwin Fagan provided the Legion many medieval and Byzantine objects, Franco-Flemish tapestries, and Romanesque and Gothic sculptures. In the 1980s, the museum's ceramics holdings were enhanced by the gift of the Bowles collection of English and French porcelain. Constance and Henry Bowles collected avidly, and this donation continues to grow through the generosity of Henry Bowles's widow, Constance Bowles Peabody.

Mr. and Mrs. Moore S. Achenbach created the Achenbach Foundation for Graphic Arts in 1948 and gave all of their works on paper to the city of San Francisco. First placed in the San Francisco Public Library, the collection was moved to the Legion of Honor in 1950. This enormous collection became the foundation for the museum's department of prints and drawings. The holdings now span the period from the end of the 15th century to the present time, including early old-master prints and drawings, Japanese prints, Indian

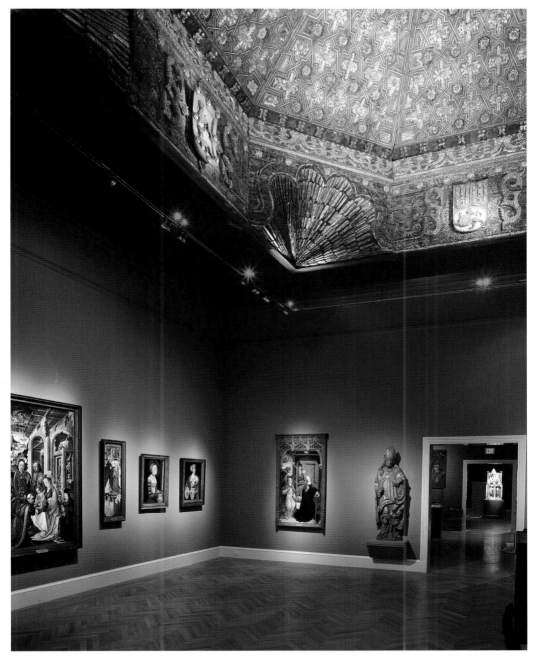

Gallery 3, featuring the ceiling (1482–1503) from the Palacio de Altamira in Torrijos, Spain (see page 47). Photograph by Richard Barnes

miniatures, photography, modern and contemporary graphics, and artists' books. The Achenbach's endowment bequest and gifts of other donors, including generous contributions of artists' books from the Reva and David Logan Collection of Illustrated Books, have increased this area such that it is now the largest collection of works of art on paper in the western United States.

Two years after Alma de Bretteville Spreckels's death in 1968, the trustees of the Legion of Honor and the M. H. de Young Memorial Museum in Golden Gate Park decided to unite the two museums under a single administrative head, and the collections were carefully merged. The new institution was named the Fine Arts Museums of San Francisco, and Ian McKibbin White, director of the Legion, was asked to become head of both museums. Under his direction, the Fine Arts Museums grew to become the primary public arts institution in San Francisco and one of the largest art museums in America. Over time the artworks have been divided between the two museums so that the Legion now houses the combined collections of antiquities and European art, as well as the works of art on paper at the Achenbach Foundation for Graphic Arts. The de Young features American art of all periods and media, Western and non-Western textiles, and the arts of Africa, Oceania, and the Americas.

With the merger, the Legion acquired several important collections from the de Young, including that of Roscoe and Margaret Oakes, with paintings representing the great schools of Dutch, Flemish, and British art of the 17th, 18th, and 19th centuries. Among the paintings in this collection are important works by Rembrandt van Rijn, Peter Paul Rubens, Anthony van Dyck, Thomas Gainsborough, Joshua Reynolds, and Henry Raeburn. The Oakeses also provided a generous fund for art acquisition that continues to allow the museum to purchase masterpieces such as *Saint John the Baptist Preaching* by Mattia Preti, the sculpture *The Orator* by Pablo Picasso, and a 9th-century-BC Assyrian wall relief from the Palace of Ashurnasirpal II.

In 1961 the de Young received a major gift from the Samuel H. Kress Collection, which was dispersed to museums throughout the United States. San Francisco received many of the finest paintings by European masters—such as *Saint Francis Venerating the Crucifix* by El Greco and *Interior with Mother and Child* by Pieter de Hooch—as well as outstanding works by Salomon van Ruysdael and Giovanni Battista Tiepolo. These are now on view at the Legion.

In the late 1960s Dr. T. Edward and Tullah Hanley made an unexpected gift of works of art to the de Young. This included many examples of exceptional interest by noted European and American artists. One important French work from this collection is Paul Gauguin's *L'arlésienne, Mme. Ginoux*, a drawing that inspired paintings by both Gauguin and Vincent van Gogh, and which is now in the Achenbach Foundation at the Legion.

Antiquities were considered an essential part of any museum in the early 20th century, and both M. H. de Young, the founder of the de Young Museum, and Alma Spreckels

furnished their institutions with a variety of ancient objects. The works they brought to their museums, and those that have been added over the years, cover broad geographical and chronological ranges within the ancient Mediterranean basin—primarily Egypt, the Near East, Greece, the Aegean Islands, Rome, and Etruria. One of the earliest and largest gifts of ancient art to the Legion was a group of antiquities received by Alma Spreckels from Elisabeth, the Queen of Greece.

The creation of the Fine Arts Museums of San Francisco under Ian White reorganized and strengthened the collections. White's successor, Harry S. Parker III, who began his tenure as director in 1987 and retired in 2005, continued to guide the dramatically trans-formed institution, adding to its national and international stature. In February 2006 John E. Buchanan, Jr., took on the responsibility as Director of Museums. With him the out-standing role the Fine Arts Museums have played as both venue and organizer for large traveling exhibitions has been enhanced and the collections continue to grow. Both the de Young and the Legion of Honor are assured a position of importance and vitality for the people of San Francisco and beyond.

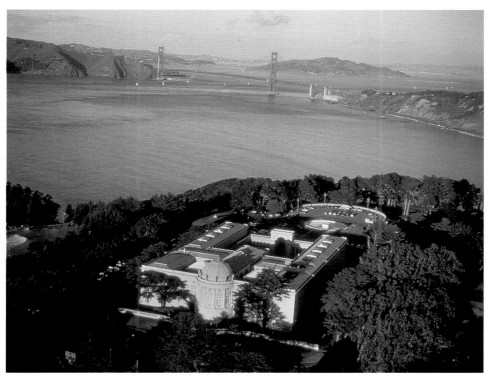

Aerial view of the Legion of Honor, overlooking the Golden Gate
Photograph by Robert Cameron

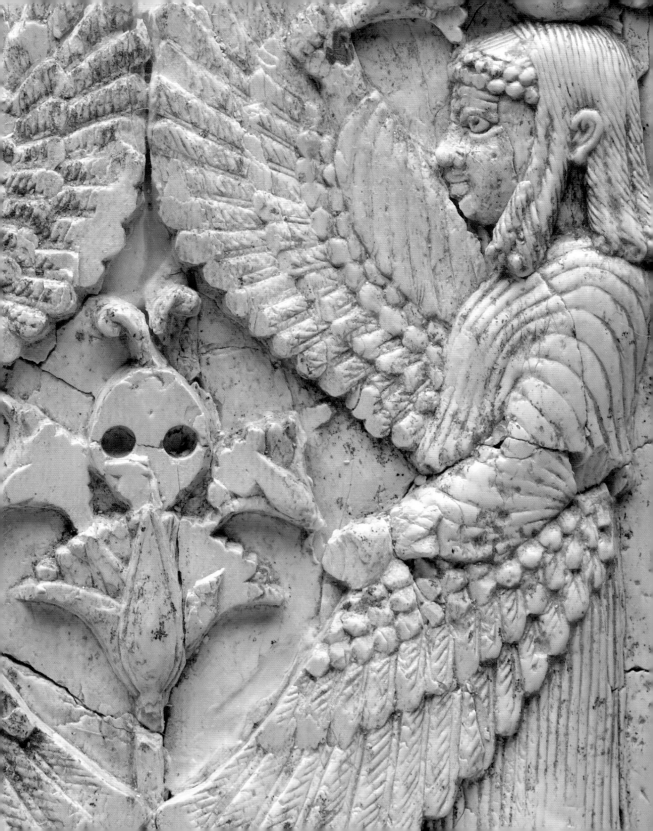

Ancient Art

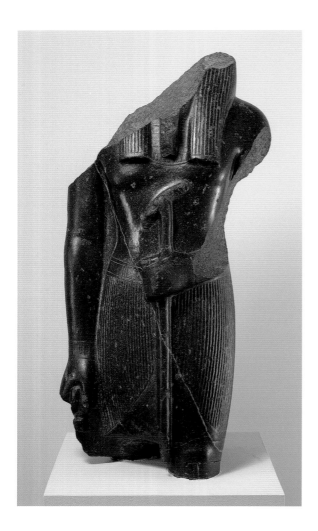

TORSO OF A GOD

Egyptian, New Kingdom,
18th Dynasty, last decade of
the reign of Amenhotep III,
1363–1353 BC

Granodiorite, H. 38 in. (96.5 cm)

Museum purchase, M. H. de Young
Endowment Fund
54661

Dating from the zenith of Egyptian art and civilization, this nearly life-size torso comes from the reign of the pharaoh Amenhotep III (1390–1352 BC) and was probably carved for his royal jubilee. Three such events, called *sed*-festivals, intended to rejuvenate the failing powers of the aging ruler and emphasize his relationship with the gods, were held during the last decade of his reign. For these occasions Amenhotep III commissioned his royal workshops to produce sets of divine statues, which were placed in temples at major sites throughout Egypt and as far south as the Sudan. In this highly polished statue, the god, who displays a similar corpulence to portraits of the king, wears a pleated linen kilt. He carries in his right hand the *ankh*, a symbol of life, while in his left he holds the *was* scepter, representing dominion. However, the loss of the head and the absence of an inscription make it impossible to identify the figure.

FEMALE FIGURINE

Egyptian, New Kingdom,
late 18th–19th Dynasty,
ca. 1350–1200 BC

Terracotta with polychrome
H. 9⅞ in. (25.1 cm)

Museum purchase, Friends of
Ian White Endowment Fund
2000.132

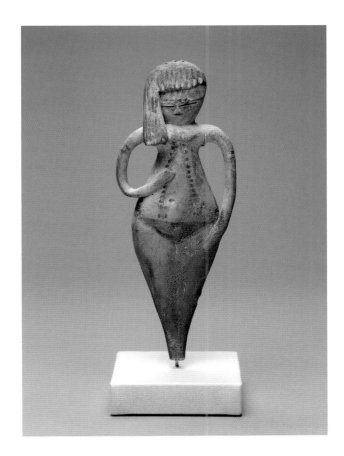

According to Egyptian convention, the nudity and sidelock of hair of this unusual, hand-modeled terracotta female figurine signify youth. Her slanted eyes are mere slits in the clay, and a ridge forms the eyebrows of her stylized disc-shaped head. There is a small, pointed nose and no perceptible mouth. The elongated body is simplified, with a narrow chest swelling to broad hips that taper toward the figure's ankles and only a mere suggestion of feet. The figure's spindly arms and hands are simple rolls of clay displaying little attempt at modeling. She wears only elaborate, brightly painted jewelry, including long tassels that fall between her breasts and extend below her navel. The figurine's nudity, exaggerated hips, and black, triangular pubic area suggest its possible function as a fertility figure.

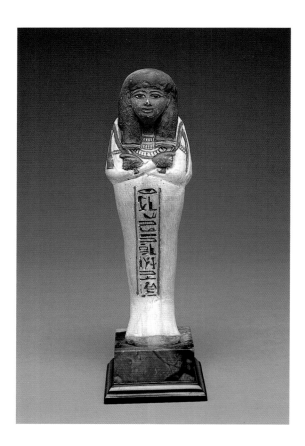

SHABTI OF SENNEDJEM
Egyptian, Deir el-Medina, New Kingdom, 19th Dynasty, reign of Ramesses II, ca. 1279–1213 BC

Limestone with polychrome
H. 9¾ in. (24.8 cm)

Gift of Adolph B. Spreckels, Jr.
1925.132

Egyptians loved life and outfitted their tombs with reliefs and objects that celebrate it. They also included anything that might lead to an enjoyable existence after death. In order for the deceased to attain the pleasures of a happy afterlife, miniature servant figures, known as *shabtis,* were included in tombs to perform any hard manual labor that the deceased might be called upon to do. This *shabti* belongs to Sennedjem, owner of Theban tomb No. 1 at Deir el-Medina on the West Bank at Luxor (ancient Thebes). He lived during the reign of Ramesses II (1279–1213 BC) and his well-known family tomb was found with its decoration and contents intact. In this brightly colored limestone example, the *shabti* is posed as a wrapped mummy with his arms crossed and is holding two hand hoes, which reflect the Egyptian belief that agricultural work would be required in the next world. The column of inscription running down the front identifies Sennedjem and offers the figure's title, "Servant in the Place of Truth."

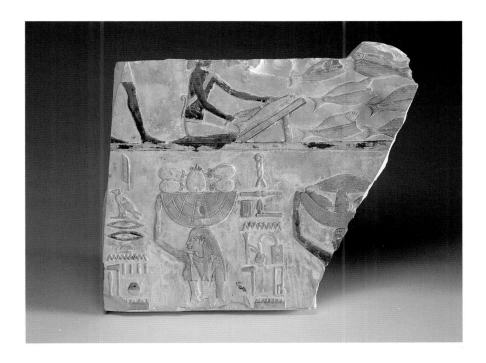

RELIEF FROM THE TOMB OF MENTUEMHAT

Egyptian, Thebes,
25th–early 26th Dynasty,
ca. 660–648 BC

Limestone with polychrome
H. 14 in. (35.6 cm)

Museum purchase, M. H.
de Young Memorial
Museum
51.4.2

No person in late Egyptian history stands out more clearly than Mentuemhat, the fourth priest of Amun, mayor of Thebes, and governor of Upper Egypt (in the south). He was the son of a prominent Theban family, and his tomb was one of the largest ever constructed in Egypt for a nonroyal. This fragment of a delicately cut wall relief, which retains most of the original paint, comes from his tomb in western Thebes. It contains portions of scenes from two registers. The lower scene shows part of a long line of offerings being brought to Mentuemhat. A man and a woman carry baskets of produce on their heads, and the vertical line of inscription designates the contents of the baskets and the owner of the provisions. The man at the right carries a basket of food, including cucumbers, loaves of bread, and a large head of lettuce. The woman holds fruit identified in the hieroglyphs as grapes. The upper register shows a man kneeling on the ground at a small, slanted table on which he cuts open a fish with a large knife. In front of him, prepared fish are displayed.

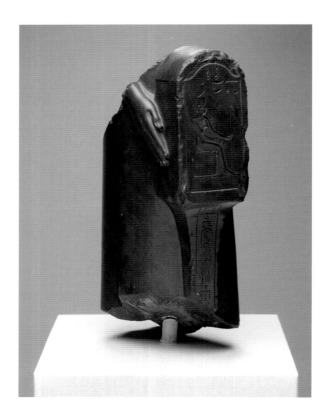

NAOPHOROS WITH THE GODDESS NEITH IN RELIEF (SHRINE HOLDER)
Egyptian, Late Period, 30th Dynasty, reign of Nectanebo I, 380–362 BC

Dark green schist, H. 13⅛ in. (33.3 cm)

Museum purchase, M. H. de Young Endowment Fund
54664

Exquisite sculpture was created during the reign of the Egyptian king Nectanebo I (380–362 BC), and this fragment is a fine example of the creativity and skill of the artists working at that time. What remains is only a portion of a standing figure wearing a long garment. Both a three-dimensional statue and a very fine hardstone relief carving, the figure, whose elegant, long fingers are still intact, holds a *naos*, or small shrine. The shrine was left solid rather than hollowed out to form a cavity for a small statue of a god, as is often the case. Instead, the artist carved a sunken relief image of the goddess "Neith, Mistress of Sais," as the inscription reveals. She wears the crown of the north, where the city of Sais was located, and holds a *was* scepter, indicating dominion, in one hand and the *ankh*, emblem of life, in the other. The text on the supporting pillar records an "Utterance by the King of Upper and Lower Egypt, Kheper-ka-ra (Nectanebo I)."

ANTHROPOID COFFIN

Egyptian, 30th Dynasty–early Ptolemaic
Period, probably 4th–3rd century BC

Cedar with traces of paint, L. 78 in.
(198.1 cm)

Museum purchase, gift of Diane B. Wilsey
in memory of Alfred S. Wilsey
2002.2a–b

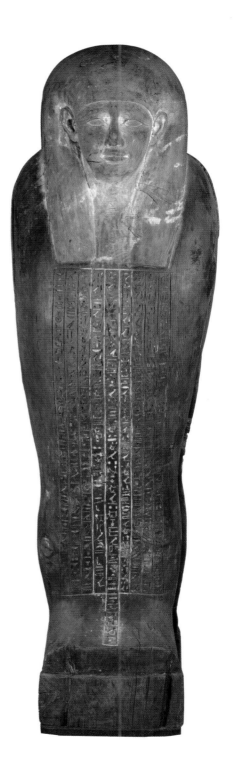

The quest for eternal life formed the core of
religion in ancient Egypt, and the afterlife
was envisioned as a continuation of an ideal
earthly existence. The ancient Egyptians
believed that the body was essential to the
survival of the spirit and was the place to
which the spirit could return to receive
sustenance and protection. The coffin func-
tioned as a substitute for the mummified
body and a surface to supply magical
images and texts. This beautifully carved
and inscribed cedar example presents a
haunting and timeless image of the coffin
as a house for the mummy and its spirit. Its
simplified form and proportions suggest
that it dates to Dynasty 30, at the end of
Egypt's Late Period, or very early in the
Ptolemaic Period (probably 4th–3rd century
BC). The inscription on the front is unusually
long and carved with great attention to
detail. Polychrome inlays were once inserted
into the glyphs and, remarkably, a few of
these remain.

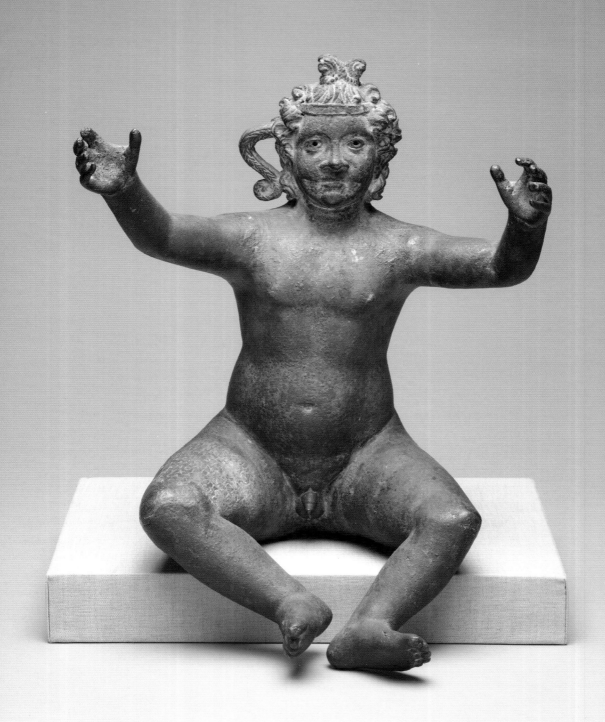

HARPOKRATES

Egyptian, Roman period, early 3rd century AD

Bronze, 16½ x 12 in. (41.9 x 30.5 cm)

Museum purchase, M. H. de Young Endowment Fund
5466

This sculpture exemplifies the Greek influence on Egyptian civilization that occurred in the wake of the reign of Alexander the Great. The seated child can be identified as the Egyptian god Horus, son of Osiris and Isis. According to Egyptian mythology, after the murder of Osiris by his brother Seth, Isis gave birth to a son, Horus, who after many ordeals triumphed over the wicked Seth. In Greek literature Horus was called Harpokrates. In this realistic bronze statue, the child god sits with his arms outstretched, as if asking to be picked up. Yet his body appears to be of a slightly older boy, and his wise face seems even more mature. The sidelock of hair on his right side, however, is a symbol of youth in Egyptian art. This sculpture merges Egyptian artistic conventions with the traditional depiction of the Greco-Egyptian deity Harpokrates, who is identified with the Greek baby god Eros. The Greek inscription on the statue's right thigh reveals that it was dedicated to a god, perhaps Harpokrates.

LION-SHAPED RHYTON (LIBATION VESSEL)

Kültepe (Anatolia), Assyrian Colony period,
ca. 1860–1780 BC

Terracotta with polychrome
H. 7½ in. (19.1 cm)

Gift of the Queen of Greece through Alma de Bretteville Spreckels
1924.15

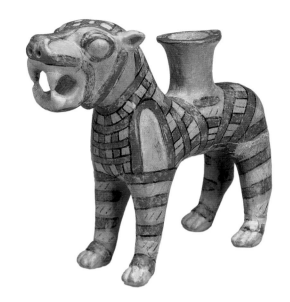

In north Mesopotamia, between about 1920 and 1850 BC, Assyrian merchants from the city of Assur on the Tigris River (today in northern Iraq) traded with a network of multicultural colonies known as *karum*, or markets, set up in central Anatolia (modern Turkey). The Assyrians collected tin from the mountains of Afghanistan to the east and fine textiles from Babylonia in the south. These goods were loaded onto caravans traveling to the *karum,* where they were exchanged for silver and gold, a portion of which was sent back to Assyria. This highly stylized, lion-shaped terracotta vessel, with a tall spout on its back and pierced nostrils for pouring, comes from Kanish (now known as Kültepe in Cappadocia), foremost among the Assyrian settlements. The Anatolians produced remarkable animal-shaped vessels during this extraordinary period, unique in the history of ancient Turkey, when these trading partners exchanged goods as well as artistic conventions.

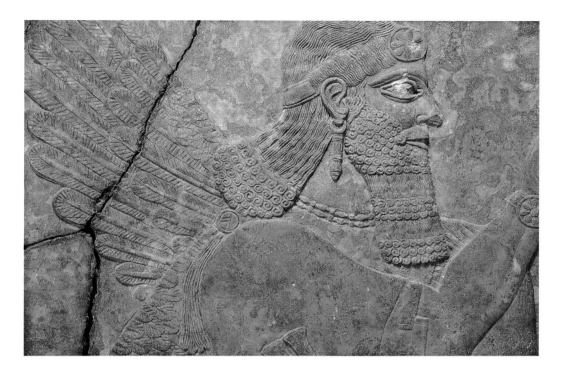

WINGED GENIUS

Assyrian, Nimrud, Northwest Palace of Ashurnasirpal II, 885–856 BC

Bituminous limestone
30 x 41⅛ in. (76.2 x 104.5 cm)

Museum purchase, Roscoe and Margaret Oakes Income Fund and the Walter H. and Phyllis J. Shorenstein Foundation Fund 1995.47

The mighty Assyrian empire dominated the Near East from Iran to Egypt from 883 to 626 BC, and its art, which ranks as one of the finest achievements of the ancient Mesopotamian world, exercised an important influence on the art of other cultures. Imposing relief sculpture, like this protective spirit from the walls of the palace of King Ashurnasirpal II, defined the classical style of the ancient Near East. Ashurnasirpal II lavished great attention on his royal palace, which was decorated with carved and painted stone reliefs illustrating historical narratives of the might and invincibility of Assyria. Other slabs had a religious or magical function. In this relief, a guardian divinity, or genius, protects the king, whose image originally stood between two winged figures. The idealized and highly political art of the Assyrians depicted the king and the human and divine members of his court with calm and dignity, since they symbolized Assyrian supremacy.

PLAQUES FROM NIMRUD

Syro-Phoenician, Fort Shalmaneser, Nimrud,
8th–7th century BC

Ivory
a) 4³⁄₁₆ x 1¾ in. (10.7 x 4.4 cm)
b) 4¾ x 3¾ in. (12 x 9.6 cm)
c) 3⁷⁄₁₆ x 2⅜ in. (8.7 x 6 cm)
d) 2¼ x 2½ in. (5.7 x 6.3 cm)
e) 3⅛ x 2¹¹⁄₁₆ in. (7.9 x 6.8 cm)

From the British School of Archaeology in Iraq
Museum purchase, William H. Noble Bequest Fund
1980.54.1–5

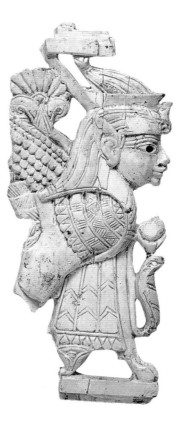

a

Excavations that began in the mid-19th century at the Assyrian capital of Nimrud brought to light the largest and finest collection of carved ivories known from the ancient world. The Museums' selection of Nimrud ivories represents a cross-section of international motifs common in the early 1st millennium BC and reflects the cultures of the Near East and Mediterranean world. Although the plaques were found in an Assyrian city, neither their design nor their craftsmanship is Assyrian. The Syro-Phoenician artists who carved these delicate ivories borrowed heavily from Egyptian art. The highly prized luxury pieces were applied as decorative inlays on furniture. They date from a time when the Greek world was still in its dark ages. Greece eventually looked to the East for its innovative elements of style and iconography. The Syro-Phoenician decorative arts, such as these rare and beautiful ivories, were to help lay the foundations for Western art.

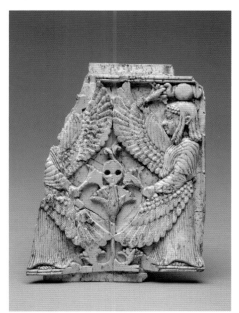

b

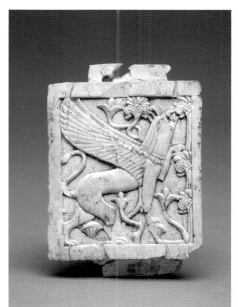

c

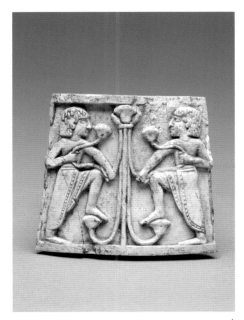

d

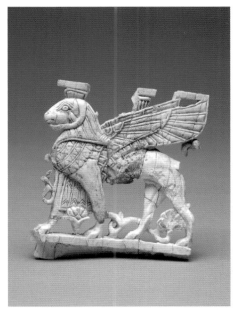

e

CYCLADIC FIGURE

Attributed to the Goulandris Master

Greek, Early Cycladic II, late Spedos variety, ca. 2500 BC

Marble, H. 13⅜ in. (34 cm)

Museum purchase, William H. Noble Bequest Fund
1981.42

Nearly five thousand years ago in the Cyclades—a cluster of small islands dotting the center of the Aegean Sea—curiously modern and abstract marble figures were carved that were severely simple in form. These figures represent the human body in its most pure, pristine, compact, and essential shape, and bear a striking resemblance to modern works of art. The most impressive and memorable type is the canonical or folded-arm figure, carved according to strict conventions, which is nearly always a nude female with the left arm placed above the right. This figure, with its long, lyre-shaped head, a semi-conical nose, sloping shoulders, narrow arms, and rounded back without any indication of a spine has been identified as the work of an artist known as the Goulandris Master. In the 20th century artists such as Picasso, Matisse, Brancusi, Arp, and Moore respected and collected Cycladic art as models of how one can create emotionally stirring, yet highly abstracted, forms.

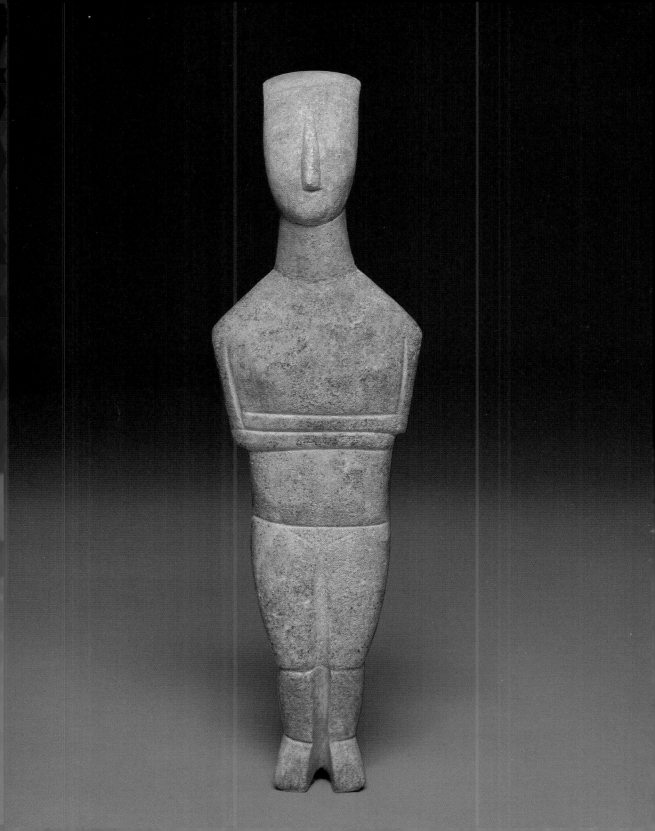

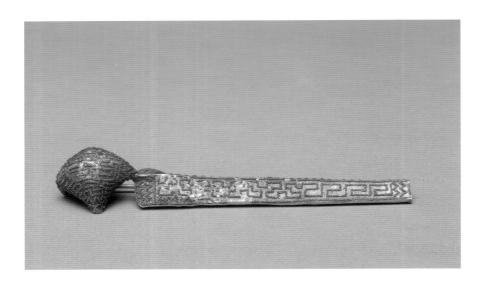

FIBULA (PIN)

Etruscan, late 7th–early 6th century BC

Gold, L. 4 in. (10.2 cm), 9.5 grams

California Midwinter International Exposition,
through M. H. de Young
391

Throughout time, gold's unique features of beauty, rarity, malleability, and durability have made it a precious material reserved for the most important and costly of objects. In addition, it possesses the almost magical property of being resistant to decay and tarnish. As a result, ancient examples, like this pin, have been preserved practically intact. This glorious Etruscan *fibula*, or safety pin, is decorated with elaborate patterns created by finely executed granulation, consisting of tiny gold balls soldered to the smooth gold surface. The raised granules reveal the degree of skill attained by the Etruscan goldsmiths. This sophisticated metalworking technique, in which the balls are adhered without melting during the soldering, has been rediscovered only recently. Even today it is difficult to form granules this small. The design on this *fibula* is made in the form of interlocking meanders with zigzag patterns at the corners and edges.

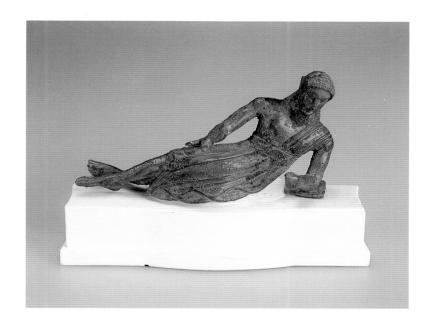

STATUETTE OF A RECLINING BANQUETER

Etruscan, late 6th–early 5th century BC

Cast and incised bronze, L. 4½ in. (11.4 cm)

Gift of Arthur Sachs
1952.26

During the Late Archaic period, Etruscan artists working in bronze gained acclaim for their inventiveness and skill. Small bronze figures such as this statuette adorned implements and utensils of various kinds, serving as handles, supports, finials, or decorative motifs to lavish luxury on ordinary and practical objects. This lively and spirited reclining youth, leaning with his left elbow on a cushion, was most likely one of several similar banqueters attached to the rim of a large vessel. Adorning a profusely decorated bronze feast bowl, this figurine might appear as if he were taking part in the celebration. He wears an intricately patterned garment with ornamented borders and a delicately incised allover pattern of punched circles joined by engraved lines that represent embroidery. The statuette dates to a time when Etruscan art was closely related to Greek art, which also made use of small sculptures for decorative purposes.

BLACK-FIGURE AMPHORA (STORAGE JAR)

Attributed to a painter of the Leagros Group
Greek, Athens, ca. 530–520 BC

Terracotta, H. (with lid) 28½ in. (73 cm)

Gift of M. H. de Young
24874.1–2

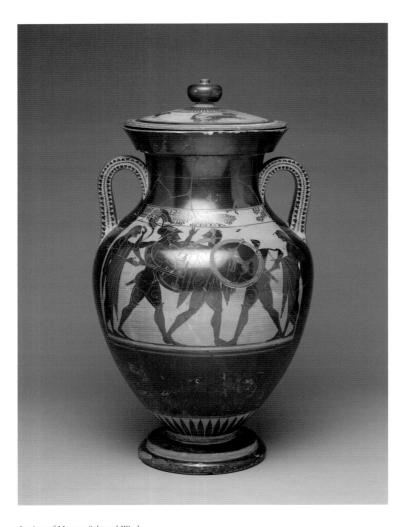

Made at the end of the 6th century BC, this very fine, lidded amphora was used as a storage vessel for wine, milk, or perhaps pickled fish. The depiction of Dionysos, god of wine, on one side of the vase suggests it might have been used to store wine. In the vigorously painted, complex main scene on the other panel, warriors, who may represent the Homeric heroes Ajax and Odysseus, dispute the claim to the arms of Achilles. While two helpless men stand by, a peacemaker (perhaps Agamemnon) intervenes. The figures are painted in the black-figure technique, in which the design was painted in black silhouette, enlivened with incised details and accessory colors, set against a red clay background. The style of drawing, with its interest in anatomical detail and lively overlapping action, has led to the vase's attribution to the Leagros Group of Greek vase painters. These artists worked in the same workshop, and their styles are closely related.

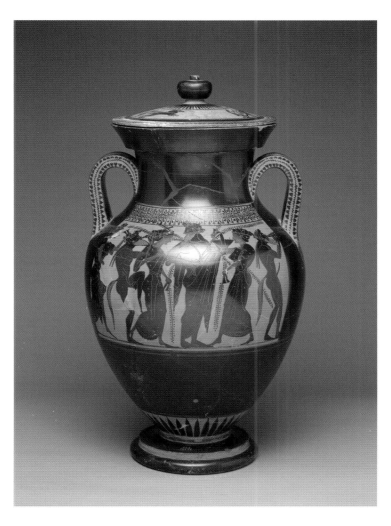

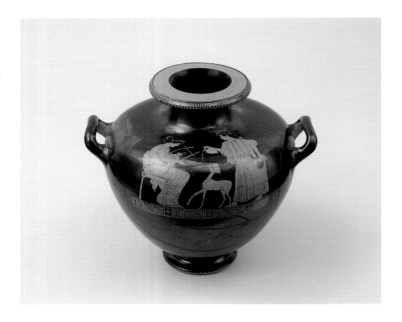

RED-FIGURE HYDRIA (WATER JAR)
Attributed to the Pan Painter
Greek, Athens, ca. 480–450 BC

Terracotta, H. 10¾ in. (27.5 cm)

California Midwinter International Exposition,
through M. H. de Young
707

In red-figure ware the figures were reserved in the color of the clay against the glazed black background; contours and inner lines were drawn in glaze. The red-figure scene on this Attic hydria has been attributed to the Pan Painter, an Early Classical artist still working in the archaizing style of his predecessors. The hydria, a pot for water, was one of the most beautiful of all the Greek vase shapes and also one of the most difficult to decorate. This gifted artist has arranged the placement of the figures so that they accentuate the curving surface. The elegantly rendered scene depicts the seated god Apollo holding a lyre. He accepts the wine poured by his sister Artemis, while her attentive fawn watches for any drops that miss the drinking cup. This mythological scene of gods serving wine to each other was popular among the Athenian vase painters.

RED-FIGURE PELIKE (STORAGE JAR)

Attributed to the Spreckels Painter
Greek, Athens, ca. 450 BC

Terracotta, H. 14⅝ in. (37.1 cm)

Gift of the Queen of Greece through
Alma de Bretteville Spreckels
1925.346.42

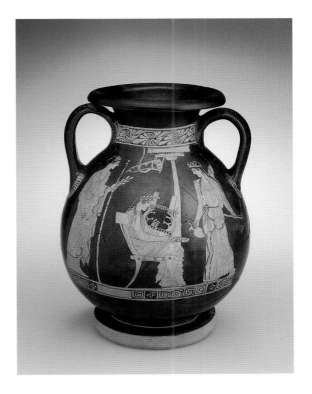

The anonymous artist who painted this lovely red-figure pelike is known only as the Spreckels Painter, named after the founder of the Legion of Honor, Alma de Bretteville Spreckels, who donated the vessel to the museum. In the main scene Leto, holding an olive branch and staff, stands behind the twin deities Apollo and Artemis, her children fathered by Zeus. Apollo sits languidly, resting a *kithara* on his lap and holding an embossed drinking cup, while Artemis, carrying her bow, pours wine for her brother (as in the hydria on the facing page). A pillar behind Apollo indicates a setting; to the left hangs his quiver, which is similar to the one Artemis carries across her back. The figures are serene and quiet, yet realistically drawn. Even the drapery falls in naturalistic folds.

PAIR OF RED-FIGURE KYLIKES (DRINKING CUPS)
APOLLO WITH HIS *KITHARA*
HERMES WITH HIS LACONIAN HOUND

Workshop of the Iliupersis Painter, attributed to the Zaandam Painter
South Italian, Apulia, ca. 375–350 BC

Terracotta, Diam. (with handles) 7¾ in. (19.7 cm)

Museum purchase, Ancient Art Trust Fund, Patricia Ann Schindler Art Acquisition
Fund, Ancient Hellenic Arts Council in Memory of Carolyn Moscarella
1999.67.1–2

From about 440 BC through the 4th century BC, red-figure ware produced in the
Greek colonies in southern Italy (Magna Graecia) rivaled the well-known painted
pottery from Athens. These two drinking cups are superb examples of the graceful
and refined vessels made in the region of Apulia during the height of this period.
Their crisp and delicate shaping and slender handles owe much to silver or bronze
examples, which must have been the prototypes for this form. The cups, clearly
made as a pair, have been attributed to an artist within the workshop of the
Iliupersis Painter, who produced some of the most important Apulian vases of the
2nd quarter of the 4th century BC and introduced elements in vase decoration that
had a profound influence on later painters. Delicately painted seated figures adorn
the center of each cup. On one the Olympian god Apollo sits between two boughs
of laurel, tuning his *kithara*. On the other, the god Hermes feeds or playfully teases
the hound reclining at his side.

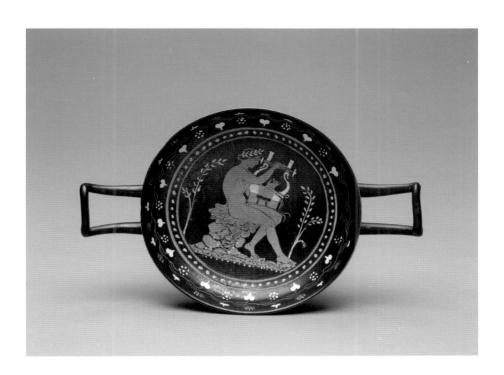

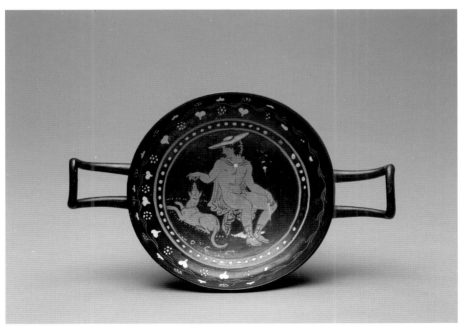

VOLUTE-KRATER (WINE VESSEL)
Attributed to the Baltimore Painter
South Italian, Apulia, ca. 330–320 BC

Terracotta, H. 42⅝ in. (108.3 cm)

Museum purchase, Dorothy Spreckels Munn
Fund
2005.24a–b

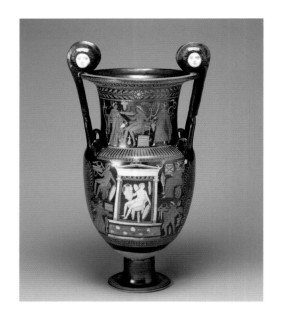

Vessels such as this impressive volute-krater from the Greek colony of Apulia show that the red-figure vases of southern Italy differ from those of Athens, although they are descended from the long-established, traditional forms of vase painting of mainland Greece. This virtuoso piece, painted about 330–320 BC, is attributed to the Baltimore Painter, one of the most important of the late Apulian painters. Its colossal size suited the South Italian taste for elaborate compositions. With superb artistic skill the artist has captured the climactic moment described in Homer's *Iliad* when Iris, the winged messenger of the gods, has come to the sulking Achilles with news that the Trojan prince Hektor may seize the body of his fallen friend Patroklos (opposite page). The Greek hero is seated on his couch in his tent, leaning on his staff. Hera, the wife of Zeus, sent Iris to persuade Achilles to return to the fray, which is portrayed in the scene below by the quadriga (four-horse-drawn chariot), perhaps driven by the Trojan hero Hektor, rampaging across the Plain of Troy.

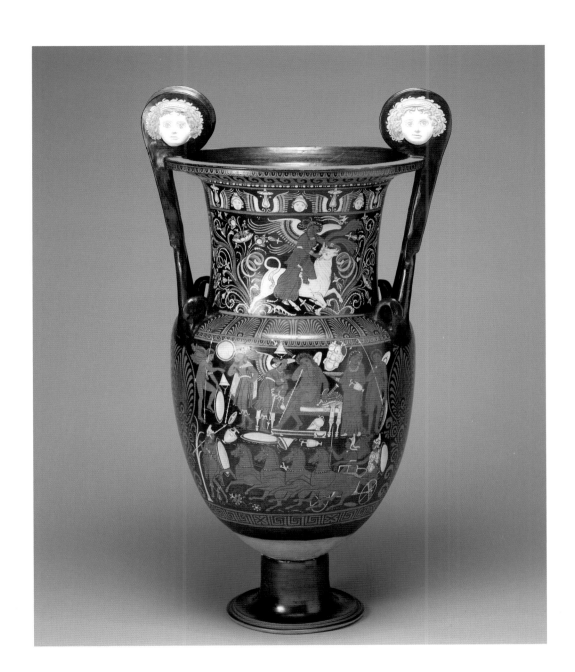

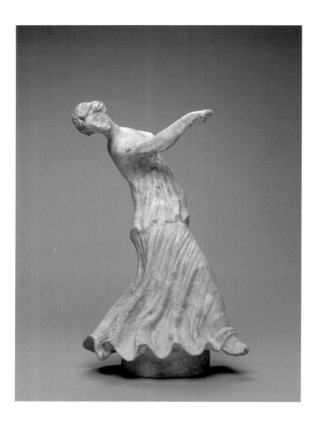

DANCING WOMAN
South Italian, Centuripe,
Sicily, 2nd century BC

Molded terracotta with traces
of polychrome, 17½ x 4¾ in.
(44.5 x 12.1 cm)

Museum purchase,
Salinger Bequest Fund
78.4

Although the Greek colonies of Magna Graecia, such as Centuripe in Sicily, remained politically independent of mainland Greece in the 2nd century BC, artistically they followed traditions established by the motherland. This dancing woman represents the merging of the sober tradition of clay figures developed in Greece with the inspiration of newer, more dramatic figures from Asia Minor. The dancer's swirling draperies, fluid movement, and elaborate gestures are characteristic of the lively, free poses favored in this period. Terracotta figures such as this example were usually cast from molds, and details were added with a pointed tool. After firing they were painted bright colors. The precise function of the figures is not known, but they were probably votive offerings at tombs or domestic shrines.

STATUE OF ASKLEPIOS, GOD OF MEDICINE

Greek, Hellenistic period,
2nd century BC

Pentelic marble, H. 36 in.
(91.4 cm)

Museum purchase, United
Hellenic American Congress
and the William H. Noble
Bequest Fund
1981.41

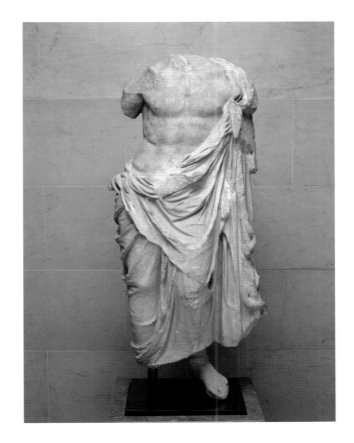

Asklepios, the son of Apollo, was the Greek god of medicine and patron of physicians. His appeal continued into early Christian times, and he was prayed to for every kind of ailment. Here he stands with his weight on his right leg, leaning on his staff, which has a serpent wound around it. The serpent was sacred to Asklepios, and his staff, the caduceus, is a symbol still used today to signify the medical profession. During the Hellenistic period there is increased realism in sculpture, which is evident in the modeling of this statue. Asklepios's right hand rests on his weight-bearing hip, which is raised in an exaggerated posture over the many deep folds of his draped *himation*. The contrasting directions representing the planes of the body and the strong folds of the drapery produce an elegant spiral twist and convey a sense of movement. The missing head would have been bearded and had a full mane of hair.

SEASON SARCOPHAGUS

Roman, AD 260–280

Marble with traces of polychrome, L. 70 in. (177.8 cm)

Museum purchase, M. H. de Young Endowment Fund
54662

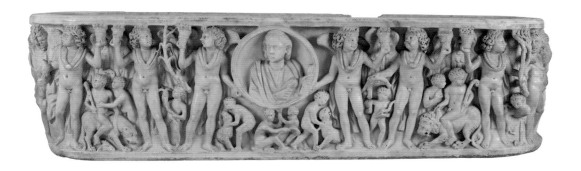

Marble sarcophagi bearing elaborate figural compositions were expensive luxuries. This sarcophagus, or coffin, contains imagery symbolic of both the agricultural seasons and Bacchic ritual. The lively imagery, sculpted in high relief, includes youths holding plants, animals, and the bounty of the harvest. The ten standing winged figures (childlike *erotes*) are carved almost in the round; their cornucopias and the wings on the two central figures supporting the roundel are freestanding. Small naked figures ride animals and engage in activities that would take place in the different seasons. The medallion contains a portrait of a noble woman, the deceased, who holds a scroll in her left hand, presumably declaring her ability to read. On coffins and other monuments of the late Roman period, youths symbolizing the seasons were popular features, perhaps expressing the transitory and reoccurring phases of life and the inevitable passage of time.

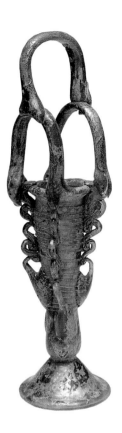

LOOP-HANDLED COSMETIC TUBE
Eastern Mediterranean, AD 4th–5th century

Free-blown glass with trailed thread decoration, H. 8⅞ in. (22.5 cm)

Gift of Helen Norton
61.14.47

Glass is one of the most versatile and ancient materials ever produced. A product of elements from the earth—sand, ashes, and lime—and heat, glass originated and developed in the ancient Near East, in Mesopotamia and Egypt. The technique of glassmaking began about 5,000 years ago, and for millennia it was used primarily for glazing objects made of other materials. Hollow vessels made entirely of glass are first known from around the middle of the 2nd millennium BC. This vessel, from the 4th–5th century AD, is an exquisite example of the glassblower's art. The discovery that molten glass could be blown into a bubble and shaped to any form was made about 50 BC, somewhere along the eastern coast of the Mediterranean Sea, and quickly spread throughout the Roman Empire. Once the basic shape of a vessel was produced, decoration and handles were added. The popularity of glass at this time rested on not only its usefulness and reasonable price but also its transparency and beauty.

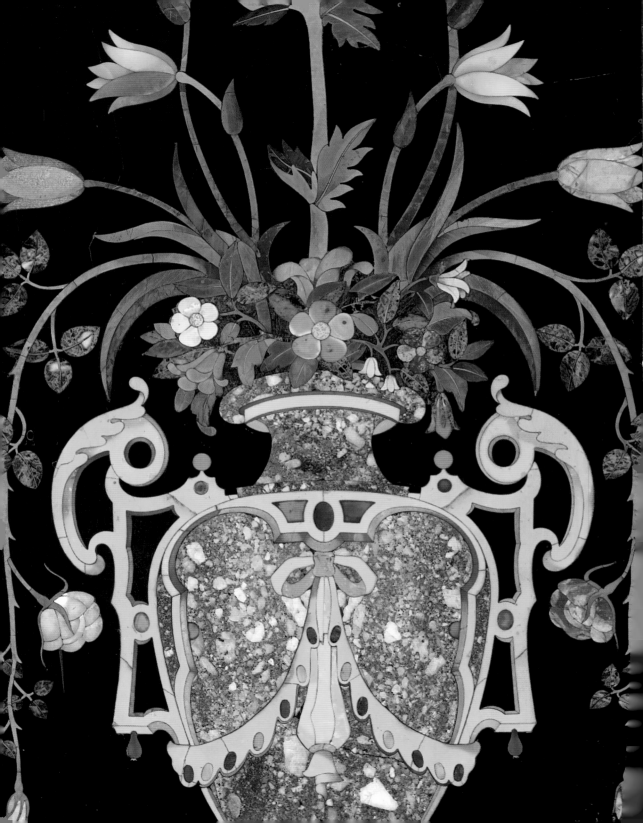

European Decorative Arts

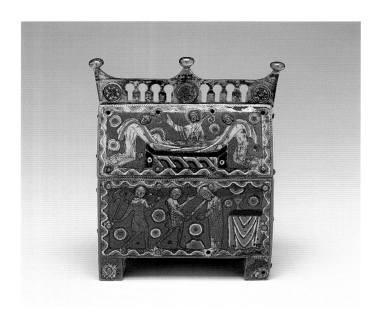

CHÂSSE WITH *THE MARTYRDOM AND ENTOMBMENT OF ST. THOMAS À BECKET*

French, Limoges, ca. 1195–1210

Champlevé enamel on copper, 6¼ x 5½ in. (15.9 x 14 cm)

Mr. and Mrs. E. John Magnin Gift
75.18.78

This *châsse*, or reliquary casket, which is part of a group of about 45 examples made in Limoges around 1200, is among the most splendid and sophisticated of the medieval enamel work produced. The demanding techniques and meticulous skills required for copper enameling were brought to their highest level by the artisans of this city. In this reliquary, the workman carved troughs, or cells, into the copper surface. These cells were then filled with vitreous enamel before the entire piece was fired. With its pitched roof and gabled ends, this portable container for the relics of revered saints echoes the shape of a church. The scene on the front depicts the martyrdom of Thomas à Becket, archbishop of Canterbury, which took place in 1170 after he opposed Henry II (1154–1189) over the battle between church and state. Becket, who was canonized three years later, rests on the roof in his shroud, ready to be deposited in a sarcophagus. Two figures of saints standing between roundels decorate the side faces. Reliquaries were often placed on altars, where the devout could venerate the relic held inside.

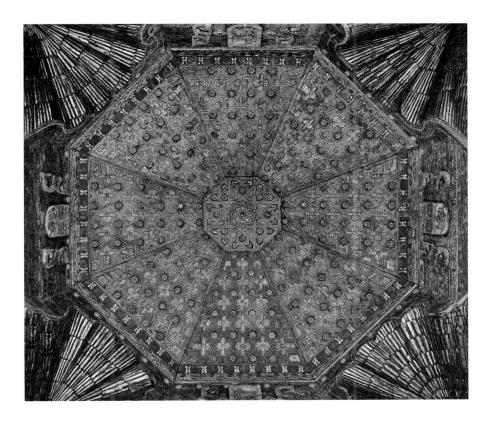

CEILING

Spanish, Torrijos, Palacio de
Altamira, 1482–1503

Painted, gilt, and composed wood
225 x 225 in. (571.5 x 571.5 cm)

Gift of Mrs. Richard Ely Danielson and
Mrs. Chauncy McCormick
46.16

This spectacular painted and gilt wooden ceiling was made in the late 15th century, near the end of the long Moorish occupation of Spain. It graced one of four towers of the Palacio de Altamira on the outskirts of Toledo. The elaborate geometric patterning of the ceiling is Islamic in origin, but Christian motifs are also in evidence. At the center of each wall panel is a coat of arms of the aristocratic Maqueda family, who were important members of the court of Isabella the Catholic. One pair belongs to Don Gutierre and his wife, Doña Teresa Enríquez. Around the top of the wall panels is a row of gilt scallop shells, which probably refer to the piety of Doña Teresa. Shells are associated with Christian pilgrimages, particularly those that were made to the shrine of St. James at Santiago de Compostella.

PANEL WITH A VASE OF FLOWERS

Attributed to Matteo Nigetti
(Italian, Florence, active early 17th century)
Italian, Opificio della Pietre Dure
(Granducal Hardstone Workshops), 1600–1650

Hardstones (lapis lazuli, amethyst, Sicilian jasper, Sienese agate, chalcedony, and carnelian), marbles (verde antico, rosso antico, bianco e nero), and alabaster, set into black Belgian marble, 52¾ x 27⅝ in. (134 x 70.2 cm)

Museum purchase, gift of Diane B. Wilsey, Roscoe and Margaret Oakes Income Fund, Raymond L. Parker Bequest Fund, Dorothy Spreckels Munn Bequest Fund, Ruth L. & Alfred B. Koch Trust; Genevieve Knowles Woods Bequest Fund; Fine Arts Museums Foundation Auction Proceeds; and the Michael Taylor Fund
2005.93

This magnificent panel is one of the finest works in hardstone made in Florence in the early 17th century. It was one of 11 mosaics that decorated the walls of the private chapel of the Medici villa at Poggio Imperiale, built outside Florence in the 1640s. The art of manufacturing hardstone mosaics (*pietre dure*) was raised to its highest point under the Medici rulers at this time. Using brilliantly colored stones and marbles, the artists of the royal workshops created mosaics designed to emulate the pavements and wall decorations of ancient Rome. These objects became the envy of princes across Europe because of their rare materials, strong coloring, technical virtuosity, and references to the past glories of antiquity. The mosaic flowers received the closest attention: ranunculus is shown in the center, flanked by tulips and roses. They are designed and cut with the greatest delicacy and naturalism in a variety of colored semiprecious stones. An innovation of the day was setting the pictorial composition against a black marble background for dramatic effect.

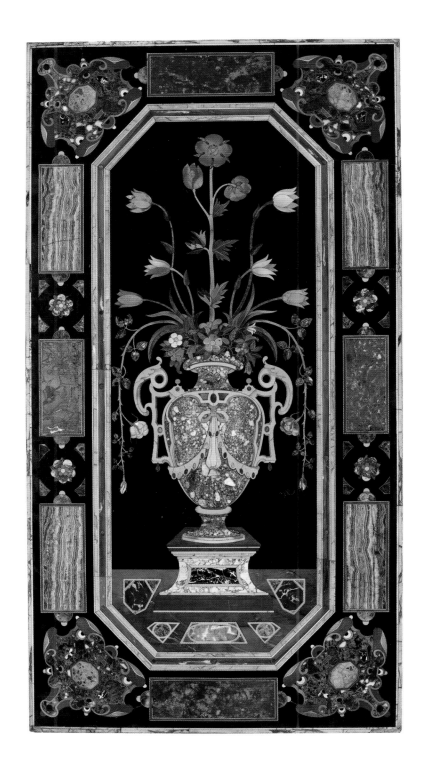

CABINET ON STAND

Attributed to Pierre Gole (French, ca. 1620–1684)
French, Paris, ca. 1650

Ebony, inlay of various woods, tinted ivory, and colored hardstones;
gilt bronze figures, 90½ x 87½ x 30 in. (229.9 x 222.3 x 76.2 cm)

Gift of William Randolph Hearst
47.20.2a–b

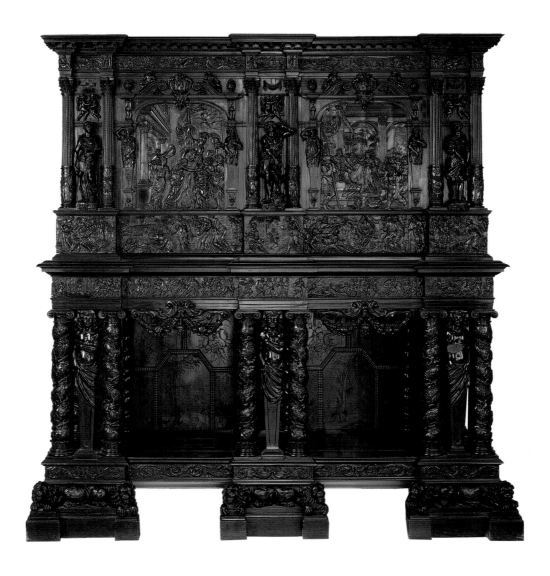

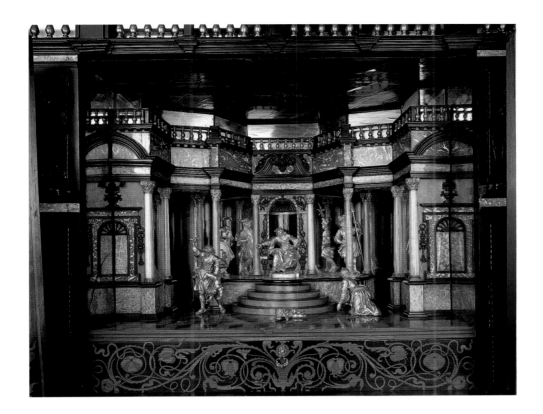

This elaborate French ebony cabinet set on a matching stand is of a type produced for the French court in the middle of the 17th century. Ebony, a dense, hard, almost black wood imported from India, was the most fashionable material for cabinets. Skilled woodworkers who made these cabinets came to be called *ébénistes,* in recognition of the wood they used most. This sumptuous cabinet is attributed to Pierre Gole, a Dutch-born craftsman who was appointed *ébéniste* for Louis XIV in 1651. The rich decoration consists of bas-reliefs inspired by contemporary prints and freestanding sculpture depicting the kings and prophets of Israel. Gole used scenes from the Old Testament as models for the reliefs on the interior and exterior of the cabinet. The carvings on the exterior doors may derive from Simon Vouet and the others from woodcuts by Jean Cousin, which appeared in the 1612 edition of Jean Le Clerc's *Figures historiques du Vieux Testament.* The doors of the cabinet open to reveal a Baroque *theatrum mundi* (theater of the world). On an ornate stage with exaggerated receding perspective, gilt-bronze figures reenact the crucial moment of the Judgment of Solomon. This scene is modeled after an engraving by Mattheas Merian the Elder (1593–1650). Concealed within this collector's cabinet are dozens of small drawers to hold precious items.

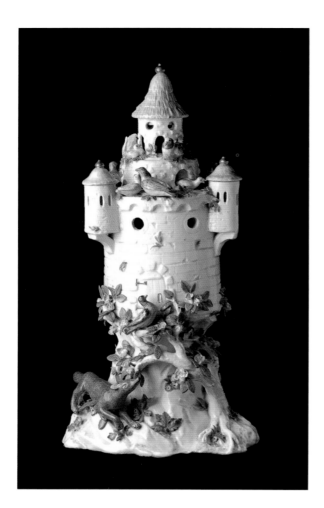

POTPOURRI IN THE SHAPE OF A DOVECOT

English, Chelsea, 1755–1756

Soft-paste porcelain, 16¾ x 8½ in. (42.5 x 21.6 cm)
Mark: red anchor

Gift of Mrs. Constance Bowles Hart in memory of Henry Bowles
1986.45a–e

The Bow and Chelsea factories were the first to produce porcelain in England, in about 1745. Naturalistic forms, either painted or modeled in porcelain, became a trademark of the Chelsea factory. This work is listed in its 1755 catalogue: "A most beautiful perfume pot, in the form of a pigeon house, with pigeons, a fox, etc." Although this subject may not be derived directly from Aesop's fables, animal subjects from these stories were particularly favored at Chelsea. This tall vase, with its complexly applied flowers, leaves, birds, and animals, is a masterwork of modeling and firing. Molded in the shape of a castle with three turrets, it is covered with 14 doves. Another dove is perched on a branch of one of the two winding trees, which grow from a rocky base, while a fox prowls expectantly below. The holes in the dovecot allowed the scent of the potpourri held within to waft into the room.

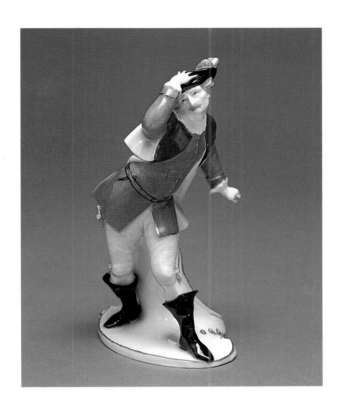

CAPITANO SPAVENTO FROM THE SERIES COMMEDIA DELL'ARTE

Modeled by Franz Anton Bustelli
(Swiss, 1723–1763)
German, Nymphenburg Factory,
1760–1763, printed ca. 1770

Hard-paste porcelain, H. 7¾ in. (19.7 cm)

Anonymous gift in honor of our parents
2004.116

The hot-headed Capitano Spavento, a character from the Italian commedia dell'arte, races forward to confront his rival, clutching a broad-brimmed feathered hat with his left hand while drawing a dagger (now lost) in his right. Bustelli was one of the most inspired Rococo porcelain artists of the mid-18th century, and this lovely example shows his signature dash, verve, and originality. His figures reflect a courtly society that is embodied in the play *Leda and Capitano*, from which the Capitano Spavento derives. This example was probably painted in its brilliant colors when it was sold from the factory in about 1770.

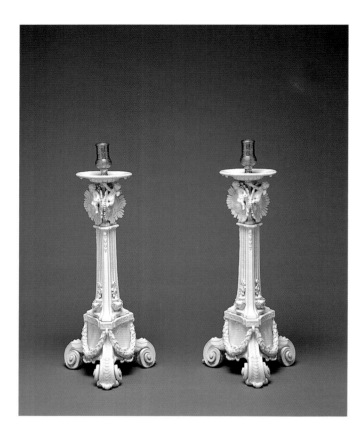

ALTAR CANDLESTICKS
Designed by Johann Joachim Kaendler (1706–1775)
German, Dresden, Meissen Factory, 1772

Hard-paste porcelain with silvered metal, 19⁵⁄₁₆ in. (49 cm)

Foundation purchase, gift of Diane B. Wilsey and the Michael
Taylor Trust
2004.112.1–2

These porcelain candlesticks are among the most inventive examples to come out of
the Meissen porcelain factory in the 1770s. Designed in the high neoclassical style,
the original version was commissioned by the elector of Saxony, Frederick Augustus
III, as a gift for Pope Clement XIV in 1770. It was one of the last orders carried
out by Johann Joachim Kaendler, the greatest modeler at Meissen, who said, "a
great deal of effort was expended in making this piece."

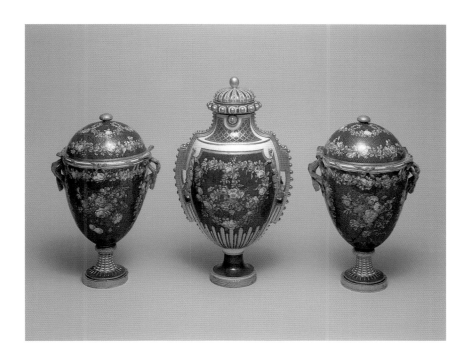

SET OF THREE COVERED VASES

French, Sèvres Factory, 1768

Soft-paste porcelain
H. center vase 19 in. (48.3 cm),
smaller vases 15½ in. (39.4 cm)

Gift of Archer M. Huntington
1927.184–186a–b

The Sèvres factory, established in 1740, produced some of the finest soft-paste porcelain in Europe. The blue ground of these vases, called *bleu Fallot* after the Sèvres worker Jean-Armand Fallot who developed the unique color in 1765, has been overpainted with an *oeil de perdrix* (partridge eye) gilding pattern. The central vase is painted front and back with bunches of fruit and flowers, which were added after areas of the ground color were scraped away to receive them. In imitation of gilt-bronze mounts, this vase has burnished gilding on the handles, the laurel swags, the lower-body gadroons, and the foot. The two flanking vessels, called *vases à oeuf* (egg-shaped), have similar floral decoration. One is marked with the date letter for 1768. The three vases may have been part of a larger *garniture* made to adorn a mantle, where they would have been reflected in a mirror.

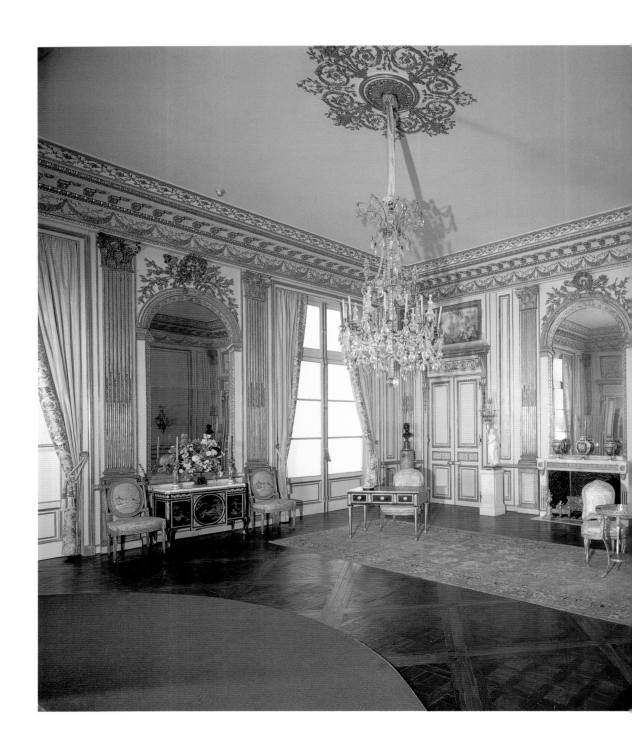

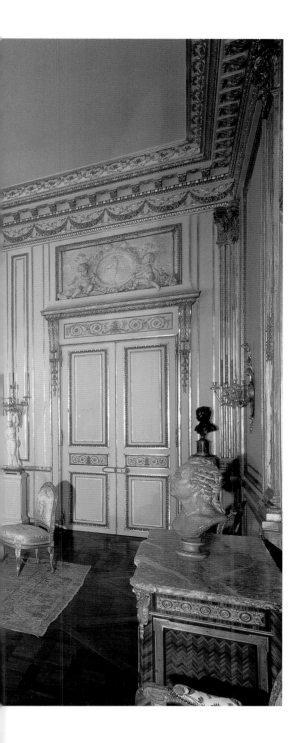

SALON

From the Hôtel d'Humières, 16 rue de
Bourbon (now 88–90 rue de Lille), Paris
French, ca. 1770–1773

Painted and gilt wood, mirror, plaster

Gift of Mr. And Mrs. Richard S. Rheem
1959.123

This sumptuous room follows the grand classical style of the Louis XVI period, with gilt architectural ornament, articulated by Corinthian pilasters flanking arched mirrors, and walls painted a light color. It comes from a house in the Faubourg St. Germain in Paris, originally built in 1716–1717 for the marquis d'Humières, grandmaster of artillery for Louis XIV. In 1728 the house passed to the duc de Gramont. The duc de Fleury, who lived there from 1750 to 1779, must have been responsible for commissioning the room's imposing interior decoration, probably from the architect Pierre-Noël Rousset. The room was moved from the house about 1900. Its gilt and ivory paneling, pilasters, fireplace, and lofty arched mirrors crowned with gilt garlands are reminiscent of the Legion of Honor building, which is inspired by the architecture of the Hôtel de Salm (now the Palais de la Légion d'Honneur) in Paris, built between 1782 and 1787.

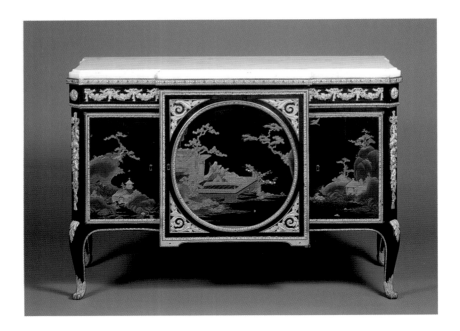

COMMODE

Martin Carlin (French, 1735–1785)
French, 1770–1780

Japanese lacquer on oak carcase with gilt bronze
mounts and marble top, 33 x 47 x 19½ in.
(83.8 x 119.4 x 49.5 cm)

Gift of Archer M. Huntington
1931.145

This is one of the finest pieces made by Martin Carlin, a German immigrant cabinetmaker working in Paris, in which he incorporated precious pieces of Japanese lacquer. These lacquered panels, decorated in relief in various tones of gold on black, were chosen with great care so that the compositions of the two flanking panels beautifully frame the extraordinary central roundel. This roundel is inlaid with a combination of sheet gold and silver and depicts two court ladies, one of whom is playing a stringed instrument. Their loose robes and long hair are typical of the Japanese Heian Court (9th–10th century), and the scene might allude to the early-11th-century *Tale of Genji*. These refined panels are held in place by gilt-bronze frames in the form of small garlands of grapes and roses tied with ribbons. This commode resembles some examples documented as belonging to Madame du Barry, mistress of Louis XV.

HOT-WATER URN
Made by Martin-Guillaume
Biennais (1764–1843,
active 1789–1819)
French, Paris, 1809–1819

Silver gilt, carnelian, H. 19¼ in.
(48.9 cm)
Inscribed: *Biennais, Orfévre*
[sic] *de S. Mté. L'Empereur
et Roi à Paris*

Gift of Alma de Bretteville
Spreckels
1944.11a–d

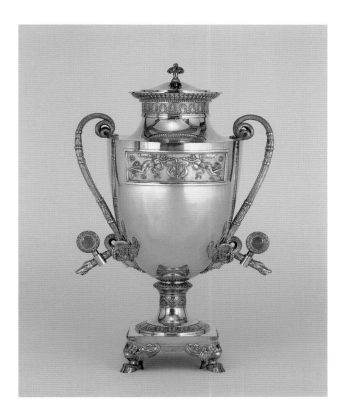

The Museums are fortunate to own a number of impressive French neoclassical pieces of silver purchased by Alma Spreckels, the founder of the Legion of Honor. This hot-water urn must have been part of one of the vast princely services made by Biennais as official goldsmith to Napoleon. One of the most versatile craftsmen of the Napoleonic era, Biennais operated an extensive workshop of highly skilled goldsmiths (some 600 workmen) who produced jewelry and large quantities of sumptuous silver for both Napoleon's entourage and the courts of Europe. Biennais modeled this piece after a tea urn (*fontaine à thé*) made by Henry Auguste in 1803 for Queen Hortense, daughter of Josephine and wife of Louis Bonaparte. Biennais may have purchased the drawing of the tea urn at Auguste's bankruptcy sale in 1810.

FALL-FRONT DESK
Made by Paolo Moschini
(1789–?)
Italian, Cremona, 1822

Elm veneer, gilt-bronze mounts
66½ x 48¾ x 26 in.
(168.9 x 123.8 x 66 cm)
Signed and dated: *Pavolo
Moschini/di Sancino/Inventò
disegnò d fece/1822*

Museum purchase, William H. Noble
Bequest Fund
78.61

With its ornate but restrained design, this classically inspired fall-front desk, commissioned from the Italian cabinetmaker Paolo Moschini in 1822, reflects a growing taste for simplicity and functionality that took hold in the early 19th century. Beneath its refined exterior, it conceals a host of secrets. Hidden safes, opened by a series of intricate mechanical devices, are contained in the upper and lower parts of this secretary. It opens into a writing desk with thirteen hidden drawers. There are two more drawers beneath those, and, on either side, six small boxlike containers move up and down with mechanisms wound by their own keys. Below the drawers, a spring-loaded safe, added later, snaps open with the press of a hidden lever. Knowing where the compartments are is not enough to open them—different keys and buttons must be used in exactly the right order, and each element is dependent on others. The desk was probably made as part of the bedroom suite of Marie-Louise of Austria, second wife of Napoleon, and later grand duchess of Parma, Piacenza, and Guastalla, for her Villa Croara at Piacenza.

TEA SERVICE AND TABLE

Peter Carl Fabergé (1846–1920)
Workmaster: Julius Rappoport
(1864–1918)
Russian, St. Petersburg, ca. 1900

Silver gilt; table veneered in Karelian
birch, H.: (table) 28¼ in. (71.8 cm),
(kettle) 13½ in. (34.4 cm)
Monogram of Victoria Melita, Grand
Duchess Kirill

Gift of Victoria Melita, Grand Duchess
Kirill, through Alma de Bretteville
Spreckels
1945.355–366.1

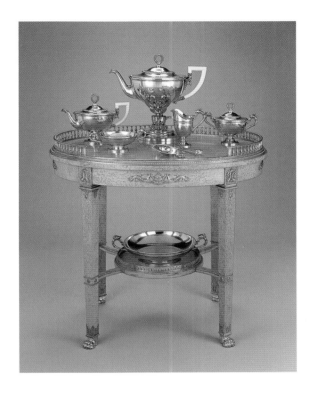

Peter Carl Fabergé, goldsmith and jeweler to the Imperial Russian Court, is well known for his splendid gold, jeweled, and enameled Easter eggs, boxes, ornaments, and adornments of all forms produced in St. Petersburg and Moscow during the reigns of Tsars Alexander III (1881–1894) and Nicholas II (1894–1917). Victoria Melita, the Grand Duchess Kirill of Russia, presented this Empire style ten-piece silver tea set with its matching silver-gilt-mounted tea table to Alma Spreckels, the founder of the Legion of Honor, on February 11, 1922, when she learned of Mrs. Spreckels's plans to build a museum in memory of Californians killed on French soil in World War I. The donor's accompanying letter reads: "Dear Mrs. Spreckels—Having heard of your wonderful new museum, & of all you are doing to help my sister the Queen of Roumania [Alma Spreckels raised money for medical supplies for Romania], I wish to present you with a golden [silver-gilt] tea service made by our famous Russian artist 'Fabergé.'—It is one of our few treasures saved & I am glad if it can find a place in the glorious monument you are building to the memory of your California soldiers."

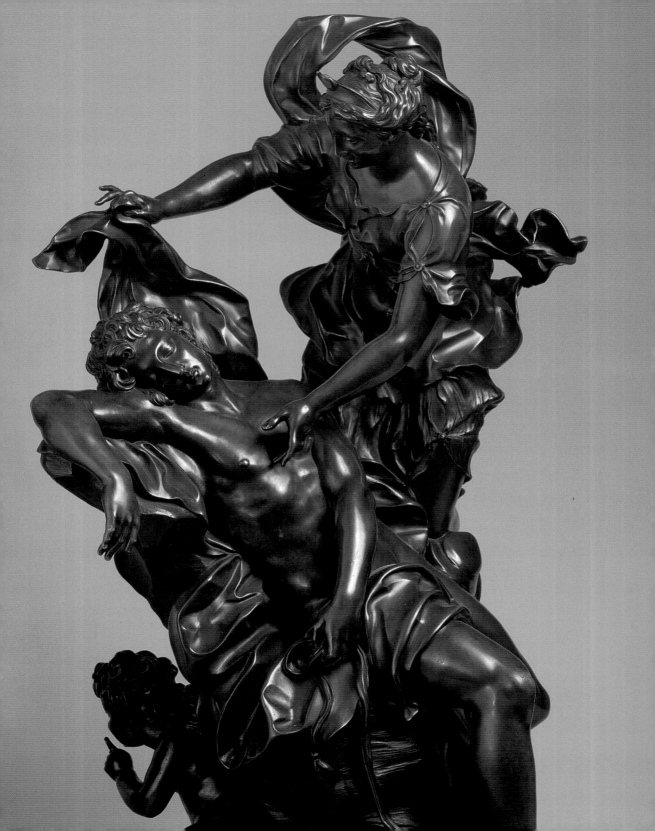

European Sculpture

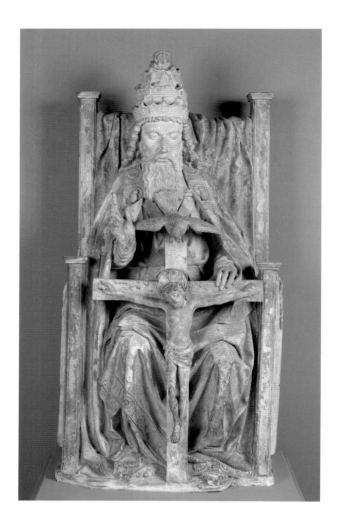

ARTIST UNKNOWN
Trinity
French, possibly Picardy, 3rd quarter of the 15th century

Limestone with traces of polychrome, 60½ x 29½ x 18 in. (153.7 x 74.9 x 45.7 cm)

Gift of The M. H. de Young Museum Society
63.11

This monumental limestone image of the Trinity expresses an idea connected with the teaching of the Roman Catholic Church, the union of the three divine beings. Each of the three figures is given distinctive form: God the Father, wearing the papal tiara and raising his right hand in blessing, sits on the throne and holds Christ on the cross, on the top of which is perched a dove symbolizing the Spirit, which focuses its gaze on Christ. The deep undercutting of the drapery for effects of light and shade and the incisive modeling in the face of God the Father are characteristic of this phase of French sculpture. At one time the work was covered with bright paint, some of which still remains.

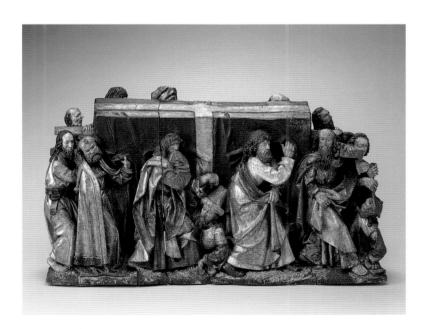

**FOLLOWER OF
ERASMUS GRASSER**
(German, Munich, 1450–1526)
Burial of the Virgin, late
15th century

Polychromed and gilt wood
20¼ x 34½ in. (51.4 x 87.6 cm)

Gift of Mr. and Mrs. Ralph C. Lee
48.9

Erasmus Grasser is Munich's best-known medieval sculptor, whose work dominated south Bavarian sculpture for some years. In this colorful narrative relief, which is likely to have been carved by Grasser or a follower, the Apostles are carrying the coffin containing the Virgin to its burial place. St. John leads the procession, carrying a palm branch, most of which has been lost. Following him, the remaining ten of the original disciples help to carry the coffin, which is covered by a black cloth decorated with a gold cross. An incident described in a popular legend of the time is illustrated by two men who have fallen under the coffin. The figure in the center, perhaps a priest, tried to touch the coffin and was paralyzed, while the one at the far right was struck by blindness. The drama of the scene is expressed by forceful gestures and postures, and the facial types are sharply differentiated, in the German tradition.

ANDREA DELLA ROBBIA

(Italian, Florence, 1437–1525)

Virgin and Child with Putti, ca. 1490–1495

Glazed terracotta, 48⅛ x 32⅛ in. (122 x 81.5 cm)

Museum purchase, Alfred S. Wilsey Memorial Fund
2003.1

Artists of the della Robbia family were major Renaissance sculptors who frequently depicted the Virgin and Child surrounded by garlands of fruit and foliage, as well as various other religious subjects. Usually installed in dwellings or religious institutions as devotional objects, the work of these Florentine artists appealed to the popular pietism of the time. Luca della Robbia (1400–1482) established the family's famed ceramic tradition. Breaking away from the customary materials of marble, stone, and bronze, he perfected sculpture in relief, developed from the technique long used in Italian pottery called *maiolica*, or tin-glazed earthenware. Andrea was the nephew and chief pupil of Luca. In this sculpture by Andrea, the beautifully rendered Virgin lovingly embraces the Child, who holds a dove, the representation of the Holy Spirit. Her sad countenance may suggest her foreknowledge of future events.

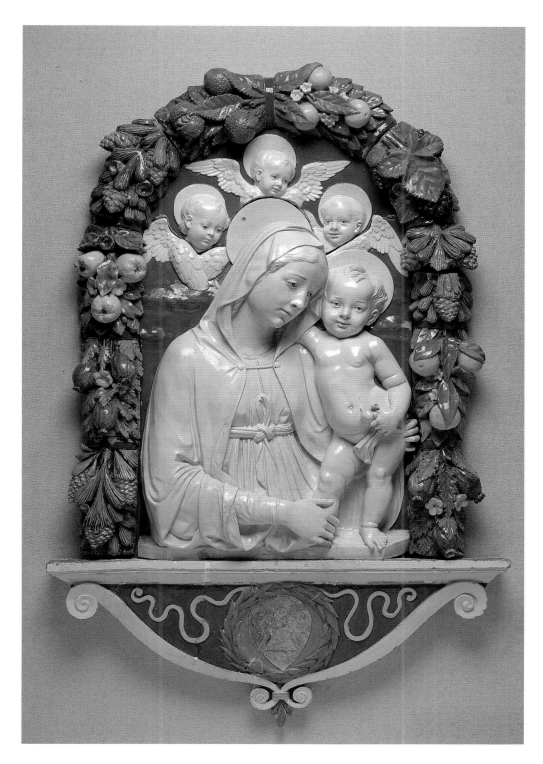

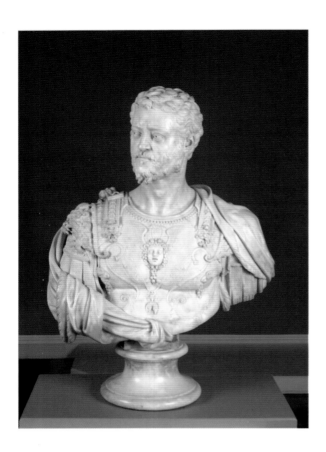

WORKSHOP OF BENVENUTO CELLINI
(Italian, Florence, 1500–1571)
*Portrait Bust of Cosimo I de'
Medici, Grand Duke of Tuscany,*
ca. 1548–1583

Pentellic marble, 37¾ x 28¼ x 15½
in. (95.9 x 71.8 x 39.4 cm)

Roscoe and Margaret Oakes
Collection
75.2.16

This marble bust of Cosimo I de' Medici depicts the Grand Duke of Tuscany with
noble bearing, dressed in classical armor. Every detail of the head and the armor has
been carved with great skill; every swirl of the beard lovingly curled. In 1547 the
Italian sculptor and goldsmith Cellini completed his acclaimed bronze portrait of
Cosimo de' Medici, which is now in the Bargello Museum in Florence. This superb
marble copy, slightly reduced in size, is from a working model for the bronze and
was perhaps commissioned by the duke. A document of 1548 states that the artist
purchased the fine Greek marble for this piece and a companion portrait of the
Grand Duchess Eleonora of Toledo (now lost) from Rome. Both of these busts
were in Cellini's studio at his death in 1571. However, the soft style of the carving
suggests that Cellini's assistant, Antonio Lorenzi, or perhaps Giambologna, who
had a workshop in the Palazzo Vecchio, completed the work.

LORENZO OTTONI

(Italian, Rome, 1648–1736)

Portrait Bust of Maffeo Barberini, Prince of Palestrina, ca. 1685–1687

Carrara marble, H. 29⅛ in. (74 cm)

Museum purchase, Roscoe and Margaret Oakes Income Fund 1984.80

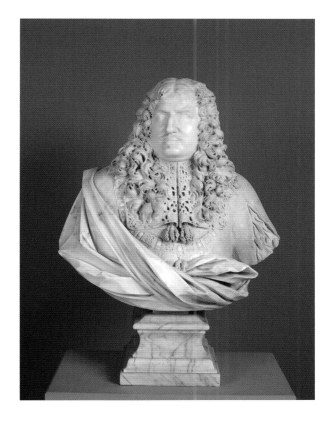

Ottoni's portrait of Maffeo Barberini is an outstanding example of the virtuoso carving of late Baroque sculptors in Rome. This prolific artist, who was involved in many of the most important public and private sculptural projects in Rome, used drills to render the flamelike locks of hair that frame his subject's face, with its distant and rather imperious expression. These locks of hair are played off against the intricate patterning of the wide lace collar, from which hang two perforated tassels. Maffeo's elevated status as a prince is underscored by his Order of the Golden Fleece, a richly embroidered doublet, and his cloak sweeping dramatically across his chest. The bust belongs to a series of portraits of the cardinals and princes from one of the most powerful families of 17th-century Rome. Maffeo's older brother, Cardinal Carlo Barberini, commissioned the series in 1685–1687. The portrait was sculpted posthumously, after a painting by Carlo Maratta. The terracotta model for the bust is still owned by the Barberini family.

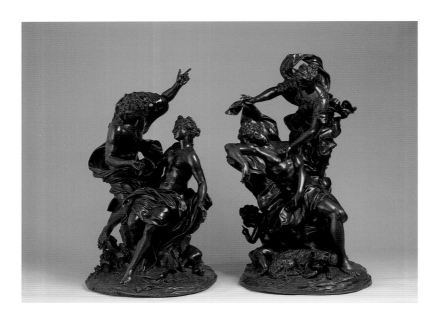

A fondness for thematic groups is a characteristic of French statuary of the early 18th century. These classically inspired bronzes were certainly conceived as a pair, as casts of the subjects by van Clève were exhibited together in the Paris Salon of 1704. A version of *Selene and Endymion* is listed in the 1715 inventory of the collection of Augustus the Strong in Dresden. The *Bacchus and Ariadne* may reflect the marble group of the same subject planned by van Clève in 1702 for Louis XIV's château at Marly. Endymion, a handsome shepherd boy from Asia Minor, was the mortal lover of the moon goddess Selene. Cast into a deep and everlasting sleep in an eternally youthful state, he was visited nightly by the adoring goddess. In the other bronze group Ariadne, the princess of Crete, who had been abandoned on the island of Naxos by Theseus, is discovered by Bacchus, the god of wine, who is taken by her great beauty. Both the god Bacchus and the goddess Selene are rendered in hovering poses, each in a spiraling composition.

CORNEILLE VAN CLÈVE
(French, Paris, 1645–1732)
Bacchus and Ariadne, ca. 1704
Selene and Endymion, ca. 1704

Bronze, H. 27½ in. (69.9 cm)
Bronze, H. 30 in. (76.2 cm)

Gift of Archer M. Huntington
1931.153–154

ATTRIBUTED TO TOMMASO SOLARI
(Italian, Genoa, d. 1779)
Equestrian Statue of Charles III, ca. 1762
(King of Naples and Sicily, 1734–1759;
King of Spain, 1759–1788)

Wax, H. 30 in. (76.2 cm)

Museum purchase, Mildred Anna Williams
Collection
1978.8

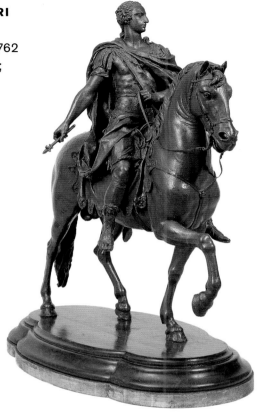

This wax sketch for an equestrian statue of Charles III of Spain was intended for Luigi Vanvitelli's design of 1757 for the Largo dello Spirito Santo (now Piazza Dante) in Naples. The first design was made for the proposed statue by the little-known sculptor Giuseppe Canart, who planned a monument similar to the famous Roman equestrian statue of Marcus Aurelius. Although Canart made a wax model, he had not begun work on this statue by the time Charles VII of Naples left for Madrid to become king of Spain in 1759. In 1762 Solari was commissioned to complete the project. This highly finished sculpture, attributed to Solari, could have been a presentation model. It follows the prancing type of equestrian statues of Louis XIV and Louis XV, in which the subject's arm is extended, rather than the animated, rearing type preferred by the Spanish monarchs of the 17th century. Being of French Bourbon lineage, the king may have changed the pose in a desire to identify with the classical image of authority favored by the French. Solari's full-scale stucco model was exhibited in 1764, but by 1767 the city's funds were depleted and the project was abandoned.

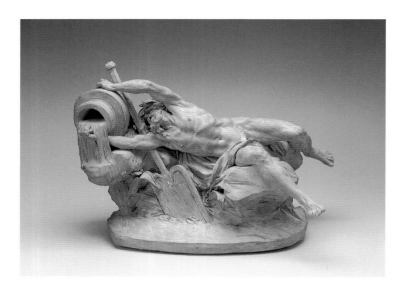

CLODION (CLAUDE MICHEL)
(French, Paris, 1738–1814)
*River God (The River Rhine Separating
the Waters)*, 1765

Terracotta, 12⅛ x 18 in. (30.8 x 45.7 cm)

Museum purchase, gift of various donors by
exchange and Whitney Warren Jr. Bequest Fund
in memory of Mrs. Adolph B. Spreckels
1989.17

Claude Michel, known as Clodion, was one of the most creative and technically gifted
French sculptors of the second half of the 18th century. Trained in the exuberant style of
the Roman Baroque, he developed a sculptural language of broad, spontaneous modeling
and decorative vigor also associated with the Rococo style. A skillful modeler of clay, he
created a new genre in sculpture, the terracotta statuette, whose subjects were most often
mythological, focusing on erotic themes of gods, nymphs, satyrs, and beautiful youths.
This dynamic terracotta representation of the river god was created relatively early in
Clodion's career when he was intent on creating monumental sculpture influenced by the
style of ancient Rome and its Baroque reinterpretation. The muscular, heroic body of the
river god and the composition's powerful, horizontal thrust reveal Clodion's response to these
traditions, while the delicate, spirited modeling shows an 18th-century sensibility. The
sculpture was probably intended as a model for a fountain.

JEAN-ANTOINE HOUDON
(French, 1741–1828)
*Portrait Bust of Madame
Adrien-Cyprien Duquesnoy*,
ca. 1805

Marble, H. 26¾ in. (68 cm)

Roscoe and Margaret Oakes
Collection
54.9

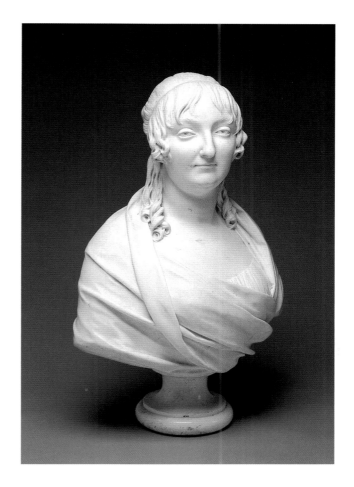

Madame Duquesnoy was the wife of the mayor of Nancy. Beginning in 1804 her husband also served as mayor of the 10th *arrondissement* of Paris, and in 1805 he presided over the marriage of Houdon's eldest daughter. This bust has a companion piece representing Monsieur Duquesnoy, signed by Houdon (now in the Musée du Louvre). The portrait of Madame Duquesnoy came to the Fine Arts Museums' collection from her family. Houdon, whose virtuoso carving imparts an unparalleled naturalism, was probably the greatest French sculptor of the 18th century. While the restrained details of Madame Duquesnoy's costume suggest a date early in the Directoire era (1795–1799), her melancholic expression is more consistent with Houdon's work from about 1805.

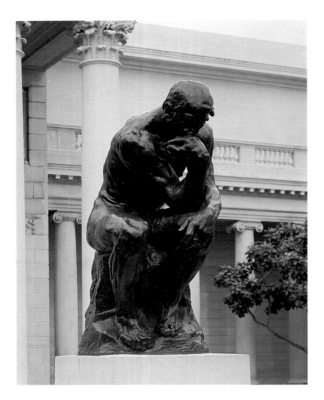

AUGUSTE RODIN
(French, 1840–1917)
The Thinker, ca. 1880,
cast ca. 1904

Bronze, H. 6 ft. 6 in. (2 m)
Signed: *A. Rodin;* stamped:
Alexis Rudier/Fondeur. Paris.

Gift of Alma de Bretteville Spreckels
1924.18.1

Rodin's *Thinker* is perhaps his best-known monumental work, first conceived about 1880 as the poet Dante. The figure evolved until it no longer represented Dante, but all poets or creators. *The Thinker* was designed to occupy the center of the tympanum of *The Gates of Hell,* which was intended to be a portal of a new Musée des Arts Décoratifs in Paris, although it was envisioned as an independent figure almost from the time the *Gates* were composed. It was exhibited in Paris in 1889 at the Exposition Monet-Rodin at the Galerie Georges Petit. A bronze cast dated 1896 at the Musée d'Art et d'Histoire in Geneva reproduces the original 27-inch version. The first over-life-size enlargement was exhibited at the Paris Salon of 1904. At that time a subscription was begun for the most famous cast of the sculpture, that for the city of Paris, which was placed in front of the Panthéon. Bronze casts of the large *Thinker* were made by a professional *reducteur* working under the artist's supervision. Rodin turned principally to the founder Alexis Rudier for his casts, and the Fine Arts Museums' example is one of several commissioned during Rodin's lifetime. Alma Spreckels purchased it from the artist in 1915 through their mutual friend Loïe Fuller. It is one of the earliest acquisitions of the more than 70 Rodin sculptures that Mrs. Spreckels purchased and later donated to the Legion of Honor.

**ARISTIDE-JOSEPH-
BONAVENTURE MAILLOL**

(French, Paris, 1861–1944)
Alexis Rudier Foundry
Torso of L'Ile de France, 1921

Gilt bronze, 30 x 14 x 22¼ in.
(76.2 x 35.6 x 56.5 cm)

Museum purchase, Mildred Anna
Williams Fund
1974.9

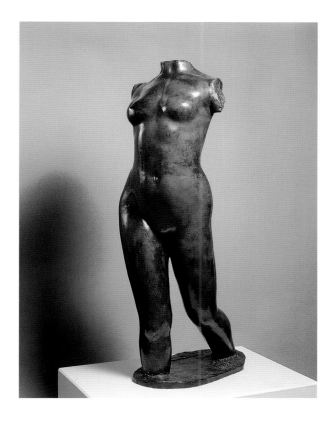

One of the major figures of 20th-century sculpture, Maillol is best known for his representations of the female figure in its perfect form. Of these, his personifications of the Ile de France are considered some of his most iconic images. This series was also one of Maillol's longest projects, appearing in a number of forms over a 15-year period. Here, in torso form, the timeless female figure seems to be striding forward with quiet, confident power. Its balanced and harmonious posture is reminiscent of a classical Nike, the goddess of victory, although the form reaches into the past to create something new. Maillol's work played an important role in the development of modern sculpture in the 20th century. In modernist fashion, this piece illustrates the tension between the forces around a central axis and an equally powerful force moving outward.

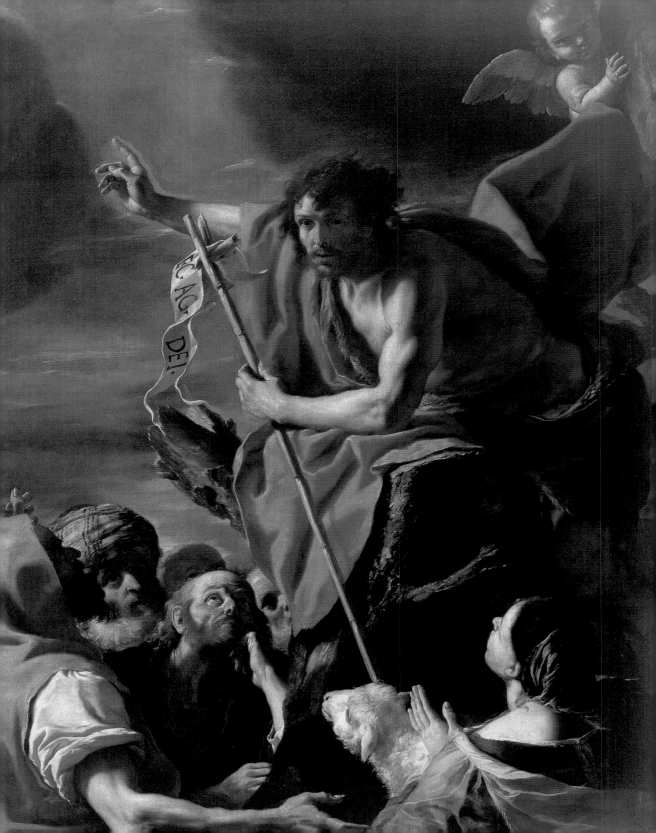

European Painting

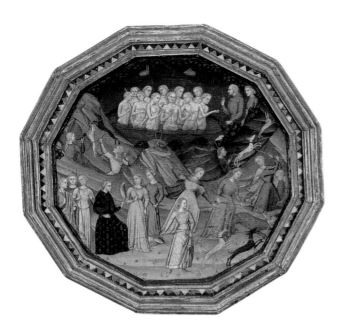

CIRCLE OF LORENZO DE NICCOLÒ

(Italian, Florence, active 1392–1412)
Desco da Parto (Birth Salver), ca. 1400

Obverse: Diana and Acteon
Reverse: Justice

Tempera on panel, Diam. 19¼ in. (48.9 cm)

Museum purchase, Roscoe and Margaret Oakes Income Fund 78.78

This unusual double-sided painting is an early Renaissance *desco*, a decorated salver or tray. It is one of only about two dozen surviving examples of Florentine presentation pieces commissioned and given in celebration of the union of two families at the time of the birth of a child. Here, as in other examples, the decorative program alludes to contemporary dynastic concerns such as chastity and family lineage. Narrative scenes derived from Ovid's *Metamorphoses* decorate the principal (obverse) side of the *desco*. The artist, relying on classical iconography, illustrates Diana, goddess of the hunt. She appears in the foreground clothed in a dark, brocaded robe and carrying a falcon; at the right, her nymphs pursue a boar. At the top, Diana is depicted in a pool surrounded by her companions as the mortal Acteon happens upon the bathing goddess. For offending the virgin deity, the unfortunate Acteon was transformed into a stag to be hunted down by his own dogs. His fate is illustrated on the left side, where a deer is chased by hounds. On the reverse of the tray an enthroned allegorical figure of Justice, flanked by two family coats of arms, holds a balance and a sword.

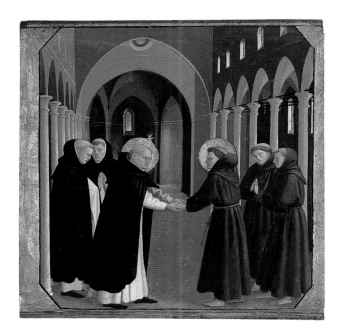

FRA ANGELICO
(Italian, Florence, active 1417–1455)
The Meeting of Saint Francis and Saint Dominic, ca. 1430

Tempera on poplar wood panel
10¼ x 10½ in. (26 x 26.7 cm)

Gift of the Samuel H. Kress Foundation
61.44.7

Guido di Piero, universally known as Fra Angelico, was an established artist when he joined the Dominican order. He led the most prestigious workshop in Florence and went on to become the foremost painter in Rome. This panel shows the founders of two Christian orders clasping hands in an austere, unembellished interior of a church. The episode of Saint Dominic recognizing and embracing Saint Francis was rarely portrayed in art before Fra Angelico's many paintings of the subject. Although Dominic had never seen Francis before the encounter, he knew him immediately as the humble friar praised by the Virgin in his dream. This small panel originally belonged to a sequence of five scenes painted on a single plank of wood, creating a predella, or decorative support, for an altarpiece. Three of the other related scenes have been identified through similarities of style, dimension, and the decorative gold borders cut at the corners. This panel would have been at the far right end of the predella, as the oblique view of the church was specifically designed for this position.

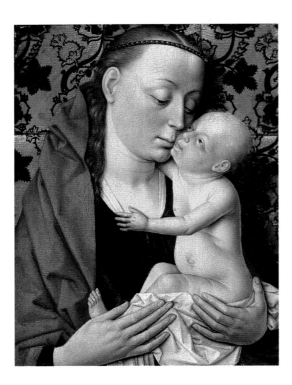

DIERIC BOUTS
(Flemish, 1415–1475)
AND/OR WORKSHOP
Virgin and Child, ca. 1475

Oil on panel, 10¼ x 7¾ in.
(26 x 19.7 cm)

Roscoe and Margaret Oakes Collection
75.2.14

This superb painting belongs to a series of images produced in response to 15th-century devotional practices. As the cult of the Virgin expanded, patrons required small panel paintings for private devotion. Tender, sometimes playful, interpretations of the Holy Mother and Child were particularly in demand in the Renaissance, reflecting the desire to present these holy personages in terms of ordinary human experience. Represented in front of a gold brocade cloth of honor signifying her royalty, the Virgin Mary and the Christ Child interact, as would any earthly mother and child. The convincing intimate embrace in this touching image emphasizes their affectionate bond, which is further accentuated by the way the two figures look directly at each other, rather than down or out toward the viewer. Upon Bouts's death his extensive and highly gifted workshop continued to produce masterworks based on his drawings.

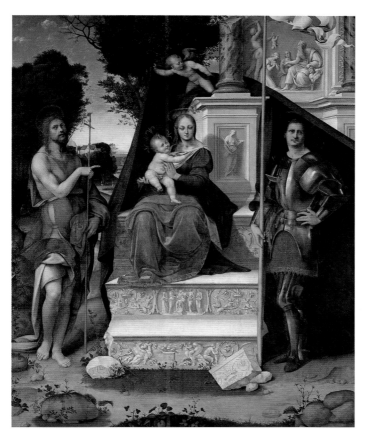

CESARE DA SESTO

(Italian, Milan, 1477–1523)
Madonna and Child with Saint John the Baptist and Saint George, ca. 1514

Oil on wood panel (transferred to pressed wood), 100¼ x 81 in. (254.6 x 205.7 cm)

Gift of the Samuel H. Kress Foundation
61.44.15

Cesare da Sesto (Il Milanese) was one of the most important artists to emerge from early 16th-century Milan, and his travels south of Rome helped to spread the ideas of the High Renaissance to painters in Naples and Sicily. This altarpiece, representing the Saints John the Baptist and George, patron saints of Genoa, was painted for the church of San Domenico in Messina, Sicily. Cesare employs a type of composition known as a *sacra conversazione*, or holy conversation, which is typical of later Renaissance depictions of the Madonna accompanied by saints. No longer relegated to subsidiary panels, the attendant saints are placed within the same space and rendered in the same scale as the Madonna and Child. Within this elegant, classically inspired scene the artist has followed Leonardo and Raphael in his use of light; the figures are softly modeled and achieve a fully developed three-dimensionality.

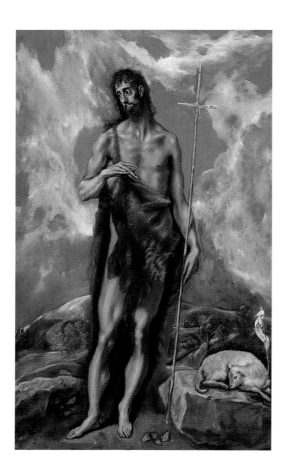

EL GRECO
(Domenikos Theotokopoulos)
(Spanish, born in Crete, 1541–1614)
St. John the Baptist, ca. 1600

Oil on canvas, 43¾ x 26 in.
(111.1 x 66 cm)

Museum purchase, funds from
various donors
46.7

El Greco used a mannerist elongation of the body to emphasize the austere, ascetic nature of Saint John the Baptist, considered the last of the Old Testament prophets to preach the coming of the Messiah and the first of the New Testament saints to acknowledge Jesus as the Messiah. To suggest the saint's spiritual energy and the intensity of his fervor, the painter activated the entire composition. The attenuated, almost sculptural figure, the agitated movement of the turbulent sky, the highly charged colors, and the scintillating light on the landscape are characteristic of El Greco's work around 1600. The lamb on the rock is a reference to Christ's sacrifice to save humankind. The banner proclaims the saint's words, [*Ecce*] *Agnus Dei*, "[Behold] the Lamb of God [who takes away the sins of the world]." This work was painted for the convent of the Discalced (barefoot) Carmelites in Malagón, Spain, where it remained until 1929. It is El Greco's most brilliant representation of Saint John the Baptist.

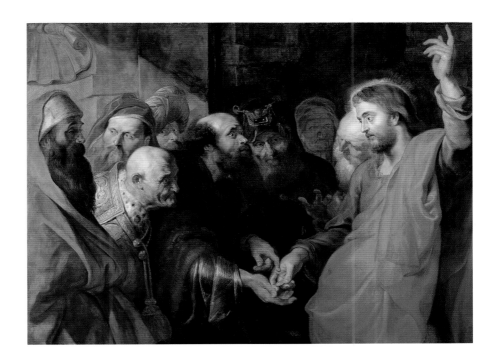

PETER PAUL RUBENS

(Flemish, 1577–1640)
The Tribute Money, ca. 1612

Oil on wood panel, 56¾ x 74¾ in.
(144.1 x 189.9 cm)

Museum purchase, M. H.
de Young Art Trust Fund
44.11

This work illustrates the crucial passage in the episode described in the New Testament, Matthew 22:15–22. In reply to the Pharisees' question about whether it is lawful to pay taxes, Christ calls attention to Caesar's image and the inscription on a coin and states, "Render therefore to Caesar the things that are Caesar's, and to God the things that are God's." This extraordinary Northern Baroque painting reflects many of the influences that the artist absorbed while in Italy between 1600 and 1608. Rubens, one of the most influential artists of the 17th century, uses light and shadow for dramatic effect. The shaft of light that cuts across the painting from the left, illuminating the faces of the bewildered Pharisees and the cluster of hands at the center, indicates a strong interest in the work of Caravaggio. *The Tribute Money* seems to have been very popular from the moment it was painted; it influenced both Jordaens and van Dyck. It was engraved in 1621, and numerous copies of it exist.

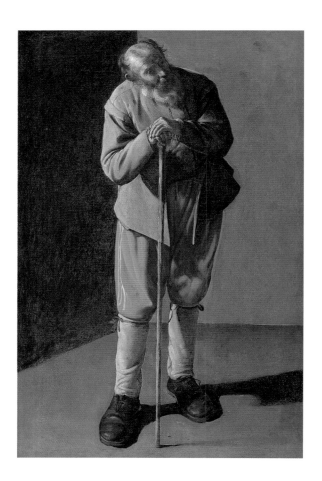

GEORGES DE LA TOUR
(French, 1593–1652)

Old Man, ca. 1618–1619
Oil on canvas, 35⅞ x 23¾ in. (91.1 x 60.3 cm)

Old Woman, ca. 1618–1619
Oil on canvas, 36 x 23⅝ in. (91.4 x 60 cm)

Roscoe and Margaret Oakes Collection
75.2.9 and 75.2.10

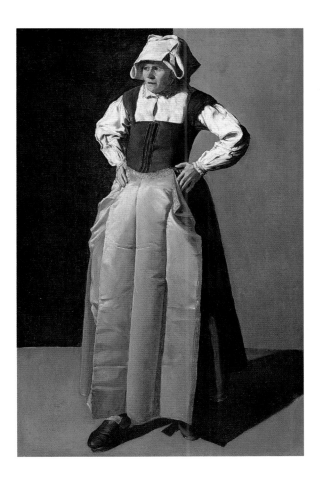

Rediscovered in the 1930s, Georges de La Tour of Lorraine is today one of the most popular French 17th-century artists. His works have been painstakingly reassembled and now number about 45 compositions, although issues of attribution and chronology remain controversial among art historians. La Tour's imagery stresses the value of human life, no matter how humble or fragile. He often depicts workers, beggars, or blind men with their physical defects and/or signs of old age clearly described. Designed as a pair, *Old Man* and *Old Woman* are among La Tour's earliest works. The figures' costumes, particularly the woman's embroidered silk apron, suggest that they are not simple peasants but rather farcical stock figures from popular theater—the irascible, domineering wife and the humiliated, hen-pecked husband. The harsh lighting effects, which emphasize the shadows and the vivid details of the figures, may come from footlights. However, this technique also shows La Tour's response to the Italian artist Caravaggio and the Utrecht masters who imitated him. Nonetheless, La Tour's skillful execution and highly refined use of color combine here to create figures of dignified monumentality.

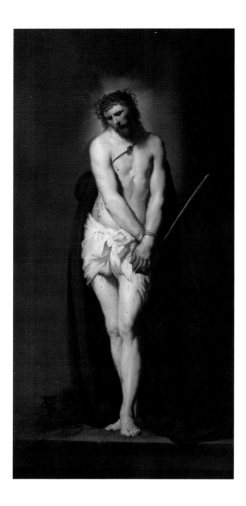

PETER FRANSZ DE GREBBER
(Dutch, 1600–1653)
Christ at the Column, 1632

Oil on panel, 63 x 33½ in. (160 x 85.1 cm)
Signed and dated: *P. DG* (in ligature) *1632*

Museum purchase, Mildred Anna Williams
Collection, Bequest Funds of Henry S. Williams
in memory of H. K. S. Williams
1995.51

One of a group of 17th-century Dutch artists known as the Haarlem Classicists, Pieter de Grebber specialized in history painting and portraiture. Religious subjects predominate among his surviving works, attesting to his close ties with the sizeable hidden communities that Roman Catholics maintained in Haarlem, Utrecht, Delft, and other cities after the Dutch provinces outlawed public practice of their religion. The imagery and monumental scale of this painting suggest it decorated the interior of one of the many clandestine churches and monasteries. In this work, which was probably an altarpiece, de Grebber presents the figure of Christ after his Roman jailers had beaten him. His flogged body, painted with delicate brushwork enhanced by translucent glazes, is bathed in dramatic, theatrical light that emphasizes the isolation and pathos of the figure. The image is both powerfully realistic and mannered, the figure's attenuated proportions heightening its emotional impact.

MATTIA PRETI
(Il Cavaliere Calabrese)
(Italian, 1613–1699)
*St. John the Baptist
Preaching*, ca. 1665

Oil on canvas, 85½ x 67 in.
(217.2 x 170.2 cm)

Museum purchase, Roscoe
and Margaret Oakes Income
Fund and Kathryn Bache
Miller Fund
1981.32

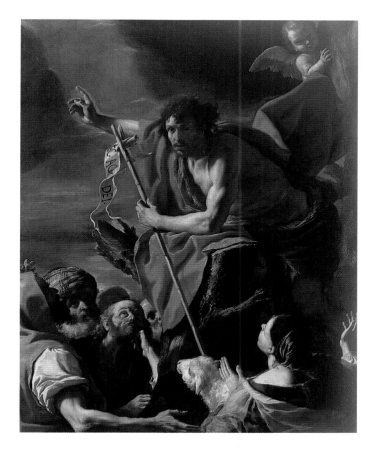

The compelling visual power of the Italian Baroque is embodied in this monumental painting from Preti's most creative phase. Characteristic of this movement, the artist attempts to draw the spectator into his dramatic painted world. The viewer is confronted directly by the gaze of a heroic, life-size Saint John the Baptist as he preaches to an audience, crowded around with rapt attention. A familiar subject during the Counter-Reformation, the Baptist symbolized the Roman church's appeal to Catholics and Protestants alike to reaffirm their belief in the Catholic faith. His pose and the staff he holds create dynamic diagonals both across and into the pictorial space. The banner on the staff reads *Ecce Agnus Dei* ("Behold the Lamb of God"), and the innocent lamb, symbolic of Christ's sacrifice, listens attentively among the people. The subject and scale of the painting, coupled with the unusual perspective from below, suggest it was designed as an altarpiece.

EUSTACHE LE SUEUR
(French, 1617–1655)
Sleeping Venus, ca. 1638–1639

Oil on canvas, 48 x 46 in. (121.9 x 116.8 cm)

Museum purchase, Mildred Anna Williams Collection
1977.10

Venus, the goddess of love, and her husband, Vulcan, the god of fire, shown in the background at his forge, shared a tumultuous union that provided delightfully provocative subject matter for artists. The myth's ancient origin helped to distance it from contemporary mores and made its licentious content acceptable. The erotic narrative, however, is only a pretext for Le Sueur's primary artistic interest: the ideal female nude. Based on an antique sculpture of a recumbent female (*Sleeping Ariadne* in the Vatican Museums), Venus's voluptuous body is turned toward the viewer, the contour creating a sinuous diagonal across the painting. The luscious red velvet curtain and Vulcan's forge express the fire of their passion. Venus's son, Cupid, gestures us to be still, as if we are voyeurs of the highly charged scene. His ruddy flesh accentuates the pale pinks of his mother's luminous, pearly skin.

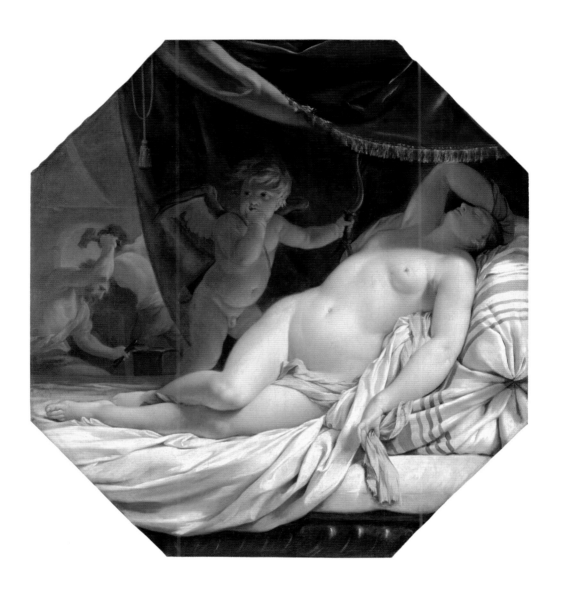

WILLEM VAN AELST
(Dutch, 1625–1683)
Flowers in a Silver Vase, 1663

Oil on canvas, 26⅝ x 21½ in. (67.6 x 54.6 cm)

Gift of Dr. and Mrs. Hermann Schuelein
51.21

Within this richly abundant floral arrangement, van Aelst incorporates a moral message through traditional symbols of time's fleeting nature and the folly of human vanity. To emphasize this message, he places tattered ribbons on the open watchcase and paints the striped tulip ready to drop its petals, while a snail begins to eat its way through a withering leaf. As emblems of inevitable decay, these objects allude to the brevity of beauty and human life and the transience of earthly pleasures and achievements. Despite its profusion of lovely blooms, *Flowers in a Silver Vase* is a subtle essay that suggests the acquisition of material wealth is a vain pursuit. Van Aelst was among the first Northern artists to work with strongly asymmetrical flower arrangements, and his dramatic lighting creates bold diagonals that activate the dynamic composition.

REMBRANDT HARMENSZ VAN RIJN

(Dutch, 1606–1669)

Joris de Caulerij, 1632

Oil on canvas (transferred to panel)
40½ x 33¾₁₆ in. (102.9 x 84.3 cm)

Roscoe and Margaret Oakes Collection
66.31

This work demonstrates the astonishing artistic power of Rembrandt at the age of 26. Newly arrived in Amsterdam from the provincial town of Leiden, he gained a reputation for beautifully crafted portraits. The exacting treatment of detail and textures, the psychological realism, and the dramatic lights, darks, shadows, and halftones in this imposing painting combine to create one of Rembrandt's outstanding early works. A document of 1654 identifies the sitter as "the Noble and Valiant Joris de Caulerij, sea-captain in the service of [the Netherlands]." In this daring and forceful pose, de Caulerij, his face partially bathed in a warm light and his left hand placed jauntily on his hip, looks out at the viewer with pride and assurance. As a member of a citizens' militia, he carries a small musket in his right hand; the bandolier and cross-hilted cavalry sword indicate that he is an officer. By 1635 he became a lieutenant in one of the six companies of militia in The Hague.

GABRIEL METSU
(Dutch, 1629–1667)
Woman Playing the Viola da Gamba, 1663

Oil on panel, 17⁵⁄₁₆ x 14³⁄₁₆ in.
(44 x 36 cm)
Signed and dated at left on
music sheets:
G Metsu A 1663

Roscoe and Margaret Oakes
Collection
60.30

Gabriel Metsu, one of 17th-century Holland's famed "little masters," produced numerous small pictures, intimate in both scale and subject. Frequently depicting Dutch interiors, these paintings were meant for private homes. Appropriately they include scenes from everyday life, considered for the first time a subject worthy of art. Music played an important role in the domestic life of the time, and this superb painting of a woman playing a viola da gamba, similar to a cello, reflects this interest. It is an outstanding example of Metsu's work, known for its remarkable range of textures, well-balanced compositions, and attention to detail, which reflects the Dutch delight in material goods. Into this charming scene, however, the artist has inserted a moralizing theme. The inclusion of the dog, an emblem of fidelity, has led to an interpretation of the painting as an essay on the virtues of marital harmony. The work is now understood as a portrait of Metsu's wife, whose birthday fell on the feast day of St. Cecilia, the patron saint of music.

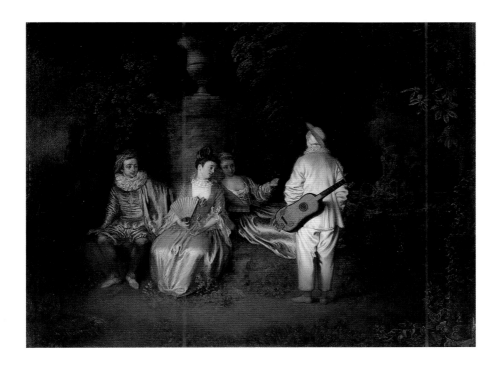

JEAN-ANTOINE WATTEAU
(French, 1684–1721)
The Foursome
(La partie quarrée), ca. 1713

Oil on canvas, 19½ x 24¾ in.
(49.5 x 62.9 cm)

Museum purchase, Mildred Anna
Williams Collection
1977.8

One of the greatest French painters, Watteau produced enigmatic work that was popular, influential, and widely collected during his lifetime. The delicate palette and luminous effects of the Rococo period characterize his intensely personal style. Influences on Watteau included the atmospheric light and color in the paintings of Rubens and the Venetian masters, whom he studied in Paris. Also important were his deep love of music and the theater. Watteau's *fêtes galantes* depict playful aristocrats, actors, and forlorn lovers in dreamlike scenes set in idealized secret gardens filled with music, conversation, and amorous dalliance. As the last rays of the sun give their costumes a brilliant sheen, four characters from the commedia dell'arte (Pierrot, Mezzetin, and their elegant companions) converse in a park. Although the term *partie quarrée* can be defined simply as a party with two couples, sexual innuendo is certainly intended. As in many of Watteau's best works, the scene layers ambiguous realities and relationships.

JEAN-BAPTISTE OUDRY

(French, 1686–1755)

The Pâté, 1743

Oil on canvas, 69¾ x 49 in.
(177.2 x 124.5 cm)

Museum purchase, Mildred Anna
Williams Collection
1956.91

The influence of the 17th-century Dutch and Flemish masters can be seen in this work by Jean-Baptiste Oudry, one of the most inventive and sensitive still-life painters in 18th-century France. A skillfully constructed architectural painting, it combines artifice and illusion into an artistic *trompe l'oeil* ("fool the eye") composition. This well-ordered arrangement of food, dead game, bottles of wine, and kitchen paraphernalia set in the framework of a niche was created for a dining-room wall and constitutes a genuinely French interpretation of a Northern format. It is a simple and classic composition, enhanced by the use of a pale palette—mainly shades of white and brown—and masterful effects of light.

GIOVANNI BATTISTA TIEPOLO
(Italian, Venice, 1696–1770)
The Empire of Flora, ca. 1743

Oil on canvas, 28¼ x 35 in. (71.8 x 88.9 cm)

Gift of the Samuel H. Kress Foundation
61.44.19

The Empire of Flora is a spirited Rococo invention, replete with verdant gardens, cavorting putti, and delightful female nudes surrounded by dazzling silk draperies. In July 1743 Count Francesco Algarotti commissioned this painting from Tiepolo, the greatest Italian painter of the 18th century, in order to present it to Count Brühl, the powerful minister of King Augustus III of Saxony and Poland. With this gift and its companion painting (*Maecenas Presenting the Arts to Augustus*, State Hermitage Museum, St. Petersburg) Algarotti hoped to win appointment to the position of Superintendent of the Royal Buildings and Collections at the court of Dresden. Sent to Dresden in 1744, the paintings were meant to flatter the count and celebrate Brühl's role as patron of the arts on behalf of his sovereign. This painting includes specific references to the count: for example, the fountain beyond the garden wall re-creates a Neptune group on the grounds of the count's country residence. Nonetheless, Brühl did not intercede on Algarotti's behalf.

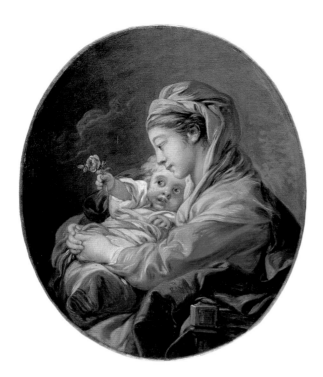

FRANÇOIS BOUCHER
(French, 1703–1770)
Virgin and Child, ca. 1765–1770

Oil on canvas, 17 x 13¾ in.
(43.2 x 34.9 cm)

Gift of Brooke Postley
57.2

François Boucher is the painter most closely identified today with the Rococo style in 18th-century France. Under the patronage of Madame de Pompadour, mistress of Louis XV, Boucher became the leading decorator of royal palaces and private residences. Throughout his career Boucher also painted religious subjects. All the charm and painterly qualities of his late work are evident in this small painting of the Virgin and Child. There is little to distinguish this devotional image from a familiar secular scene of a young mother caressing her child and gazing upon him with love. In this tender depiction, however, the rose held by the Child follows traditional Italian iconography of Santa Maria della Rosa, in which either the Virgin Mary or the infant Christ holds a rose. Following convention, the Virgin is shown half-length, wearing a red robe under a blue cloak.

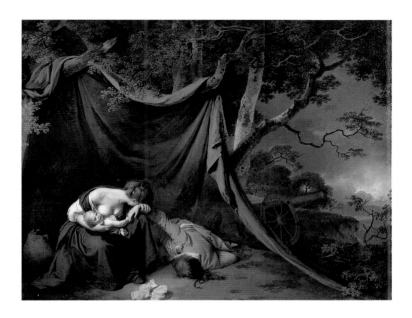

JOSEPH WRIGHT (Wright of Derby)
(English, 1734–1797)
The Dead Soldier, 1789

Oil on canvas, 40 x 50 in. (101.6 x 127 cm)
Signed and dated: *J. W. P. /1789*

Museum purchase, Roscoe and Margaret Oakes Income Fund, Estate of Don
G. Speakman, Grover Magnin Endowment Fund; Bequest Fund of Henry S.
Williams in memory of H. K. S. Williams, and the European Art Trust Fund
1998.29

Joseph Wright, born in the provincial city of Derby, became the first British artist
to gain national stature while living outside London. Called Wright of Derby, he is
widely known as the first professional painter to express the spirit of the Industrial
Revolution. Wright's *The Dead Soldier* is a large and striking narrative composition
that both expresses late-18th-century interests and anticipates the sensibilities of
the Romantic period of the early 19th century. It captures a dramatic moment
expressed in a passage from "The Country Justice," a poem by John Langhorne, a
magistrate and country justice of the peace. The poem, which was exhibited with
the painting in 1789, contemplates a fatherless child's destiny and solicits compassion
for those unfortunates who appear before the judicial bench. The painting shows a
pathetic, but sensual, young mother who grieves over the body of her child's father.

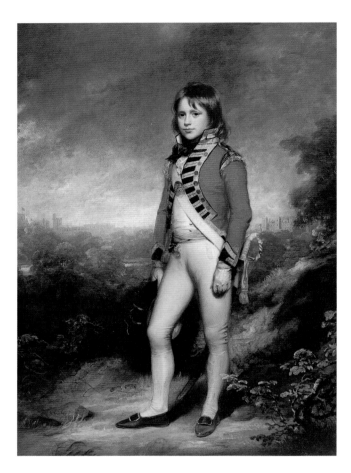

SIR WILLIAM BEECHEY
(English, 1753–1839)
Master James Hatch, 1796

Oil on canvas, 73 x 52½ in.
(185.4 x 133.4 cm)

Museum purchase by
exchange, Mildred Anna
Williams Collection
1942.10

Master James Hatch (1783–1804) is painted in the elaborate military uniform he wore as Marshall's Attendant at the Montem, one of Eton College's traditional celebrations. This procession consisted of fancifully dressed, marching boys, demanding gifts of money along the way, while banners flew and military bands played. It was a singular honor to be named Marshall's Attendant, the leader of the procession. Beechey portrayed a dignified Master Hatch standing proudly on a hill overlooking Eton College on the right and the towers of Windsor Castle on the left. The artist's palette of clear, fresh colors complements the youthful, full-length figure, which is silhouetted against a low horizon and dramatic sky. Beechey exhibited this charming picture at the Royal Academy in 1797 among a prestigious group of portraits that included four of the royal princesses, one of the queen, and one of the Prince of Wales.

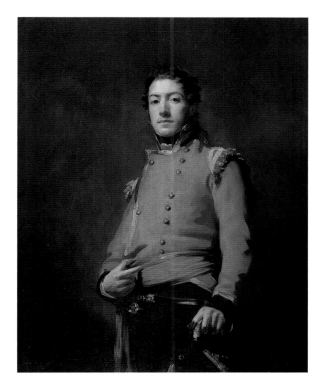

SIR HENRY RAEBURN
(Scottish, 1756–1823)
Sir Duncan Campbell of Barcaldine,
ca. 1812

Oil on canvas, 50⅜ x 40 in.
(128 x 101.6 cm)

Roscoe and Margaret Oakes Collection
75.2.12

When Raeburn painted this portrait, Duncan Campbell held double rank as lieutenant in the Third Regiment of Foot Guards (now the Scots Guards) and captain in the army. He is shown triumphant after serving with distinction in the Napoleonic wars. Around 1812 Raeburn evolved this very successful, yet simple, style for military portraits, in which the brilliantly illuminated three-quarter-length subject stands on an elevated platform. Although largely self-taught as an artist, Raeburn shows himself to be a master at capturing the sitter's personality, modeling his pronounced features in a deep, sculptural fashion. The intensely keyed color scheme of saturated red and gold, dramatically set against a dark background, accentuates the sitter's vigorous, aristocratic stance. Equally vibrant is Raeburn's lively, painterly brushwork, which delineates the forms and creates a sense of space and volume.

ELISABETH LOUISE VIGÉE LE BRUN

(French, 1755–1842)

Hyacinthe Gabrielle Roland, Later Marchioness Wellesley, 1791

Oil on canvas, 39 x 29½ in. (99.1 x 74.9 cm)

Museum purchase, Mildred Anna Williams Collection, Bequest Fund of Henry S. Williams in memory of H. K. S. Williams 1991.29

It is reported that Vigée Le Brun's father, the artist Louis Vigée, said to her, "You will be a painter, my child, if ever there was one." His prediction turned out to be true, as she became one of the most famous and successful French portraitists of the 18th century. In 1778, when only 24, Vigée Le Brun was invited to paint Marie-Antoinette and soon became the queen's official portraitist and close friend. During the French Revolution, the artist fled France but continued to paint portraits in exile throughout Europe and Russia. She painted this ravishing image of Hyacinthe Gabrielle Roland while in Rome. At that time Mademoiselle Roland was the mistress of the Earl of Mornington, later Marquess Wellesley, the elder brother of the Duke of Wellington. They married in 1794, and one of their daughters eventually became the great-great-grandmother of Queen Elizabeth II. The simple costume, vibrant colors, quick, fluent brushstrokes, and flattering likeness, which are characteristic of Vigée Le Brun's work, reveal the beauty, vivacity, and sensuality of the sitter.

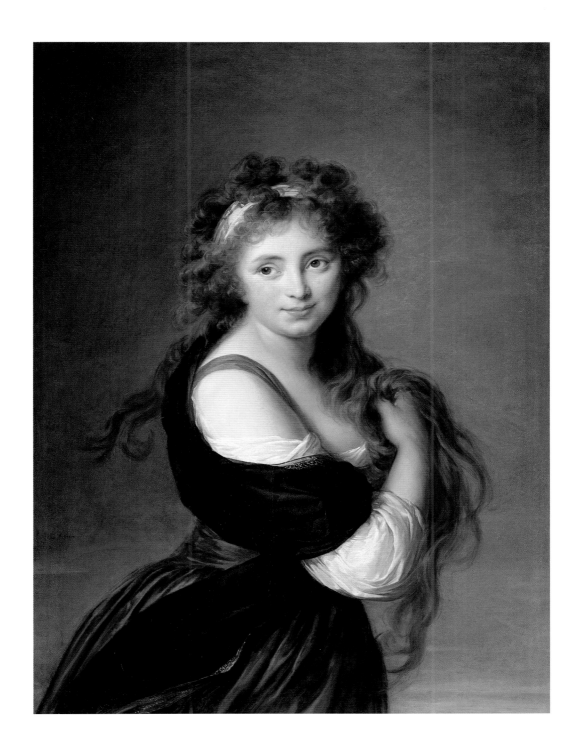

JEAN-BAPTISTE-CAMILLE COROT
(French, 1796–1875)
View of Rome: The Bridge and Castel Sant'Angelo with the Cupola of St. Peter's, 1826–1827

Oil on paper mounted on canvas
10½ x 17 in. (26.7 x 43.2 cm)
Stamped lower left corner: *Vente Corot* in red

Museum purchase, Archer M. Huntington Fund
1935.2

This remarkable, small painting was executed during Corot's first trip to Italy (1825–1828). His several views of the banks of the Tiber near the Castel Sant'Angelo all appear to have been painted outdoors, directly from nature, but none is more attentive to subtleties of light and color than this example. Indeed, its extraordinary naturalism, immediacy of impression, and luminous atmosphere have led many authorities to cite *View of Rome* as the kind of painting that directly influenced the birth of Impressionism. Corot has included some of Rome's most famous landmarks in the painting: the massive forms of the castle and the houses at the left balance the long, horizontal bridge with its graceful arches, beyond which rises the great dome of Saint Peter's Basilica.

HONORÉ DAUMIER
(French, 1808–1879)
Third-Class Carriage (Un wagon de troisième classe), ca. 1856–1858

Oil on panel, 10¼ x 13⅜ in. (26 x 33.9 cm)

Museum purchase, Whitney Warren Jr. Bequest Fund in memory of Mrs. Adolph B. Spreckels, Bequest Fund of Henry S. Williams in memory of H. K. S. Williams, Magnin Income Fund, Art Trust Fund, Alexander and Jean de Bretteville Fund, Art Acquisition Endowment Income Fund in honor of Mrs. John N. Rosekrans
1996.51

Honoré Daumier lived during an age of political and social upheaval. A keen wit and an astute observer of the human condition and urban life, he is best known for the satirical prints and incisive caricatures he contributed to various Paris papers. Moreover, as a prolific painter and sculptor, Daumier is considered an artist whose work had a profound impact on modern art. *Third-Class Carriage* illustrates his sympathy for the common man and woman involved in mundane activities. In this painting a crowd of strangers, either asleep or absorbed in their own thoughts, are pressed together in a narrow train compartment. Despite their working-class status, they are portrayed with dignity. Especially impressive is the man in the center, who has an almost noble bearing.

JOHN RODDAM SPENCER STANHOPE
(English, 1829–1908)
Love and the Maiden, 1877

Tempera, gold paint, and gold leaf on canvas,
54 x 79 in. (137.2 x 200.7 cm)
Signed on tree trunk: *RSS 1877*

Museum purchase, European Art Trust Fund,
Grover A. Magnin Bequest Fund and Dorothy
Spreckels Munn Bequest Fund
2002.176

Love and the Maiden, acknowledged to be
Stanhope's masterpiece, represents the longings
and aspirations of an artistic generation who
sought relief from the grim realities of urban
life created by the Industrial Revolution.
Bearing the hallmarks of Victorian artistry, it
was shown at the opening exhibition of the
Grosvenor Gallery in 1877, along with works
by Edward Burne-Jones and Dante Gabriel
Rossetti, a founding member of the disbanded
English Pre-Raphaelite Brotherhood. It also
exemplifies the artistic philosophy of British
Aestheticism (ca. 1860–1895), which espoused
that beauty itself is a moral force and that the
contemplation of beauty can improve people
and society. This exquisitely painted image
draws upon the stylistic and iconographic
vocabulary of the Italian Renaissance, in partic-
ular that of Botticelli. Stanhope used egg-based
tempera, the medium in which the early
Renaissance masterpieces were painted, high-
lighting his details with gold paint and gold
leaf. He was among the first modern British
artists to reintroduce this medium.

KONSTANTIN MAKOVSKY

(Russian, 1839–1915)
The Russian Bride's Attire, 1889

Oil on canvas, 110 x 147 in.
(279.4 x 373.4 cm)

Bequest of M. H. de Young
53161

This opulent narrative painting, which illustrates
the preparations for a Russian wedding among
the landed gentry, is characteristic of the grand
manner that dominated official, academic art
and taste in the 19th century. Makovsky's
painstakingly detailed costumes, interiors, and
theatrical staging found enthusiastic audiences
in Europe and America, appealing to a vogue
for romanticized narratives and the exoticism
of historical Russia. The artist painted three
large, elaborate canvases on the theme of the
Russian bride, each depicting a different
episode in an imaginative reenactment of an
incident from the early years of the Romanov
dynasty: *The Choosing of the Bride* (Museo de
Arte in Ponce, Puerto Rico), *The Russian
Bride's Attire*, and *The Boyar Wedding*
(Hillwood Museum and Gardens, Washington,
D.C.). Although Makovsky's interpretation
of history was perhaps fanciful, he nevertheless
took pains to present a convincing, yet con-
trived, tableau of 17th-century Russian life.

EDOUARD MANET
(French, 1832–1883)
At The Milliner's (Chez la modiste), 1881

Oil on canvas, 33½ x 29 in. (85.1 x 73.7 cm)

Museum purchase, Mildred Anna Williams
Collection
1957.3

Edouard Manet helped revolutionize French art through his bold and painterly depictions of contemporary life, and one of his favorite themes, especially in later life, was feminine elegance. In *At the Milliner's,* the creamy flesh of the woman's face and bare shoulders is the focus of the composition and contrasts with her diaphanous, cascading black shawl. Her exquisitely outlined profile is silhouetted against the flat, vividly patterned wallpaper, a treatment that suggests the influence of Japanese prints. The subject of women shopping in fashionable Parisian boutiques was popular among artists of the time. However, despite this painting's traditional title, the luxurious wallpaper, more appropriate to a domestic setting than a shop, and the woman's off-the-shoulder dress suggest that it may depict an intimate scene of a woman trying on a hat in the privacy of her own home.

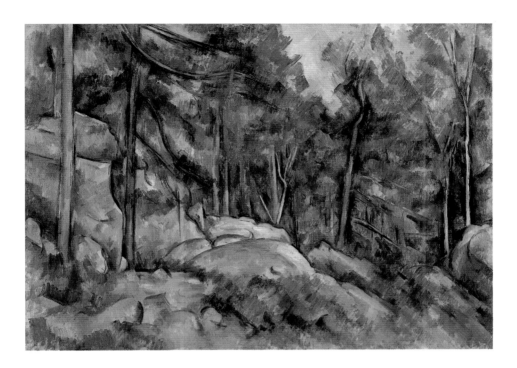

PAUL CÉZANNE
(French, 1839–1906)
Forest Interior, ca. 1898–1899

Oil on canvas, 24 x 32 in. (61 x 81.3 cm)

Museum purchase, Mildred Anna Williams Collection
1977.4

In this vigorous work Cézanne seeks to describe the inner geometry of nature, in his words, "to make of Impressionism something solid and durable, like the art of museums." Working directly from nature, he uses parallel and rhythmic brushstrokes to build up color forms, a thin watercolorlike application of pigments to enhance luminosity, and a simplification of objects into geometric shapes to create a solid substructure of patterns. Against a foundation of rounded rocks, vertical tree trunks, and diagonal limbs Cézanne handles the sky, foliage, and foreground vegetation in a loose manner. The result is a lively, balanced composition that expresses his perceptions of the dynamic play of light, space, color, and shape. The painting's site has never been positively identified, but its topographical elements are characteristic of the forests of both Fontainebleau and Provence.

GEORGE SEURAT
(French, 1859–1891)
Eiffel Tower, ca. 1889

Oil on panel, 9½ x 6 in.
(24.1 x 15.2 cm)

Museum purchase, William H. Noble
Bequest Fund
1979.48

Standing nearly 1,000 feet tall, the Eiffel Tower was the most strikingly modern statement on the Parisian skyline in 1889. However, this structure and Seurat's Post-Impressionist style were both offensive to most contemporary viewers. In 1887 a group of notable artists, writers, and intellectuals denounced the new monument as "useless and monstrous." Two years later Pissarro identified it as evidence of social turpitude and bourgeois excess. Nevertheless, Seurat celebrated the tower as a marvel of the modern industrial vernacular, its bold, but elegant, design a combination of iron, light, and space that dissolves into the surrounding sky. For the artist, the soon-to-be completed revolutionary landmark was a symbol of progress that had an affinity with his equally modern and controversial pointillist technique. In modulating his color upward from reds and oranges at the base to a lighter palette dominated by yellow, Seurat appears to have followed the iridescent enamel paint scheme used by Gustave Eiffel, who built the tower.

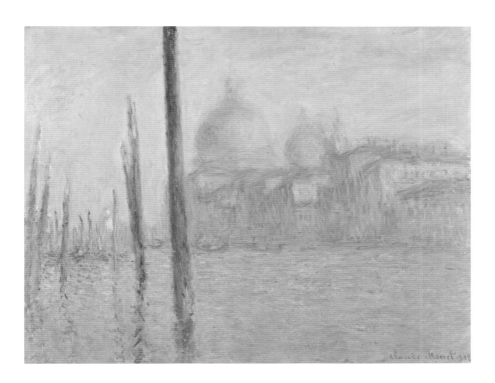

CLAUDE MONET
(French, 1840–1926)
The Grand Canal, Venice, 1908

Oil on canvas, 28¹³⁄₁₆ x 35⁵⁄₁₆ in. (73.3 x 90.8 cm)

Gift of Osgood Hooker
1960.29

Venturing out of his reclusive life in Giverny, Monet reluctantly agreed to a trip to Venice in 1908. He found the shimmering city "too beautiful to be painted" and "unrenderable." Nonetheless, he set to work on groups of canvases that expanded his interest in seriality—painting the same motif studied at different times of day. Although Monet titled the painting simply *Le Grand Canal, Venise*, he composed the work as an impressionistic glimpse of the domed church of Santa Maria della Salute. Unlike his usual method of charting the changes of time and light throughout the day, in this series Monet painted six views of the church from across the canal at the same time of day, probably in the afternoon. He captures the famous Venetian haze, through which none of the details of the buildings' forms, colors, or materials are visible. In all six versions, the most striking motifs are the vertical wooden gondola moorings, which establish a vantage point for the viewer.

PABLO PICASSO

(Spanish, 1881–1973)

Still Life with Skull, Leeks, and Pitcher, March 14, 1945

Oil on canvas, 28¾ x 45⅝ in.
(73 x 115.9 cm)
Dated upper left corner: *14 3 45*
Signed lower right corner: *Picasso*

Museum purchase, Whitney Warren Jr. Bequest Fund in memory of Mrs. Adolph B. Spreckels, Grover A. Magnin Bequest Fund, Roscoe and Margaret Oakes Income Fund, and Bequest of Mr. and Mrs. Frederick J. Hellman by exchange
1992.1

Picasso did not covet things but, as he said, he permitted them to accumulate. He lived in a world overflowing with material objects, some of which he used in his many passionate and sensual still-life compositions. Much of his work is filled with personal meanings and associations. *Still Life with Skull, Leeks, and Pitcher* reveals his obsession with life and death. It is one of a series of works painted in the spring of 1945, toward the close of World War II, when he was living and working in Paris under the constant surveillance of the Nazi occupation forces. A skull—an age-old symbol of mortality and a ubiquitous motif for Picasso—is joined by leeks, which may represent wartime scarcity but also signify the forces of life, and an exuberantly painted ceramic pitcher.

Works on Paper

ALBRECHT DÜRER

(German, 1471–1528)

Melencolia I, 1514

Engraving, M. 75–2d, B. 74, Holl. 75iia/iib
9½ x 7⁷⁄₁₆ in. (24.1 x 18.9 cm)

Achenbach Foundation for Graphic Arts
1963.30.24

Albrecht Dürer, the great German artist of the Northern Renaissance, raised the status of printmaking to a fine art, far beyond its origin as a craft. Early in his career he realized the potential of the medium for bringing art to a wide audience. His work includes a variety of subjects representing religious, historical, and allegorical themes. This exquisite impression of one of his best-known engravings is an allegory of Melancholy, one of the four human temperaments, which were of particular interest to the humanists of the Renaissance who believed that each individual was dominated by one of the four humors: sanguine, choleric, melancholic, and phlegmatic. Melancholy, thought to bring on insanity, was the least desirable. However, it also was associated with creative genius and the risks that come with it. This winged personification of a dejected Melancholy, exemplifying the emotional state of the artist, represents a spiritual self-portrait of Dürer.

ENEA VICO
(Italian, 1523–1567)
The Studio of Baccio Bandinelli, after Baccio Bandinelli, ca. 1546

Engraving, B. 49i/ii, 12⅛ x 18⅞ in. (30.9 x 47.9 cm)

Mr. and Mrs. Marcus Sopher Collection
1986.1.310

Baccio Bandinelli (1488–1560), an ambitious Florentine sculptor and lifelong rival of Michelangelo, commissioned this engraving from the printmaker Enea Vico to celebrate his achievements as a teacher and man of learning. Vico conceived Bandinelli's workshop as a gracious room filled with industrious apprentices and artists in fashionable dress bent over their tablets. Brilliant touches of light cast dramatic shadows and illuminate the hard-working assistants. By equipping the studio with books and antiquities, Vico presents the making of art as a serious, intellectual enterprise, a product of mental labor. Miniature replicas of ancient statues, sculptural fragments, and human bones appropriate for anatomical study surround the workers. Bandinelli appears at the extreme right, his noble status demonstrated by the badge of knighthood emblazoned on his clothing, a sign of the rank he had recently received from Charles V.

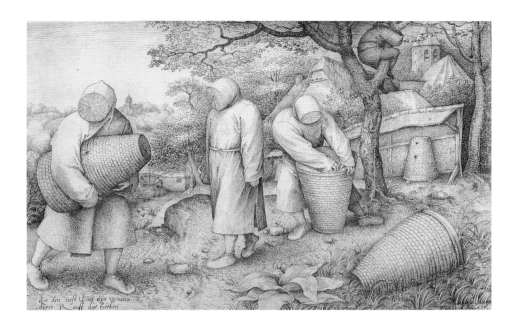

SCHOOL OF PIETER BRUEGHEL THE ELDER

(Flemish, 1528–1569)
The Beekeepers, 1567

Pen and brown ink on laid paper
8⅛ x 12⁷⁄₁₆ in. (20.6 x 31.6 cm)

Museum purchase, Achenbach Foundation for Graphic Arts
Endowment Fund and William H. Noble Bequest Fund
1978.2.31

On the edge of a village, three beekeepers in protective clothing arrange beehives while a boy climbs a tree. The scene is clarified by the inscription, translated as "He who knows the nest, knows it; he who robs the nest has it," a well-known Netherlandish proverb meaning that the active man gets the profit. Whereas the beekeepers end up with nothing, the unprotected thieving boy, suffering the consequences, wins the prize. A painting by Brueghel of 1568, *The Peasant and the Birdnester* (Kunsthistorisches Museum, Vienna), illustrates the same proverb but shows the boy actually robbing a bird's nest. Brueghel's drawing for *The Beekeepers* is in the collection of the Kupferstichkabinett, Berlin, and another workshop copy, probably of a later date, is in the British Museum. The Fine Arts Museums' drawing, possibly designed as a model for an engraving, is also a workshop copy.

REMBRANDT HARMENSZ VAN RIJN
(Dutch, 1606–1669)
Christ Crucified between Two Thieves
(The Three Crosses), 1653

Etching, drypoint, and engraving, Holl. 78iv/v, H. 270,
15⅛ x 17⅞ in. (38.5 x 45.3 cm)

Museum purchase, Achenbach Foundation for
Graphic Arts Endowment Fund
1964.142.40

Religious themes were of interest to Rembrandt throughout his prolific and successful career. This illustration of Christ's last hours on the cross is considered one of his masterpieces as a printmaker. It shows the most emotional moment of Christ's suffering, his death, when "there was darkness over the whole land" (Mark 15:33). Massive beams of supernatural light slice through the darkness and focus on the pathetic figure of Christ, one of the flanking thieves, and a small, central portion of the surrounding bystanders, while dark shadows fill the remainder of the scene. Rembrandt made several versions of this print, drastically reworking the surface to transform the composition when the plate had worn down through printing. The most dramatic changes occurred between the third and fourth states, when this powerful, extraordinary painterly work was created. New figures, including the mounted soldiers, were added; the deep lines defining Christ's body were enhanced to make him appear gaunt and emaciated; and heavier black was used to highlight the tiny crown of light around his head.

GIOVANNI FRANCESCO BARBIERI
(Guercino)
(Italian, 1591–1666)
*Saint John the Evangelist Meditating
on the Gospel*, ca. 1645–1650

Pen and brown ink on laid paper mounted
on an album page, 8½ x 7⅞ in.
(21.7 x 20 cm)

Museum purchase, Achenbach Foundation
for Graphic Arts Endowment Fund
1976.2.19

Giovanni Francesco Barbieri, nicknamed
Guercino ("squinter") after a childhood
incident that left him cross-eyed, was an
artist renowned for his innovative composi-
tions. In this superb drawing the Bolognese
artist captures a psychological insight as Saint
John the Evangelist meditates on the opening
passage of his gospel: *In principio erat verbum*
(In the beginning was the word). A brilliant
draftsman, the artist has rendered his contem-
plative subject with an elegant and refined
style. Guercino's favorite medium was a
goose-feather pen dipped in ink, which
allowed him to record his fleeting ideas on
paper. Here these rapidly drawn lines are
used to delineate and model his subject, cre-
ating smooth transitions from light to deep
shadow. The drawing's artistic excellence and
appealing subject must account for its several
etched and engraved copies.

ARTIST UNKNOWN

Indian, Rajput, Devgarh School
Horse Fight, ca. 1790

Opaque watercolor on paper mounted
on a heavier sheet, 10⅞ x 16 in.
(27.7 x 40.5 cm)

Museum collection, gift of Katherine Ball
X71.42.426

Rajput art is a style of Indian painting
that evolved and flourished during the
18th century in the royal courts of
Rajputana, India. Each Rajput kingdom
evolved a distinct style, but the styles
share certain common features. This
art is rich in variety, including portraits,
scenes from court life and literary nar-
ratives, wild life and hunting scenes,
and illustrations of battles. The lively
images are depicted in a conceptual
manner and not drawn directly from
nature, although they incorporate
realistic details. In this boldly designed
miniature, rearing and bounding horses,
brightly colored and crisply outlined,
are placed against a vivid landscape.
Men, riding bareback, fall from the
horses and run to avoid being trampled
in the melee. The work was painted in
Devgarh, a feudal state in northwestern
India where small ateliers maintained
a few artists who painted strikingly
original compositions.

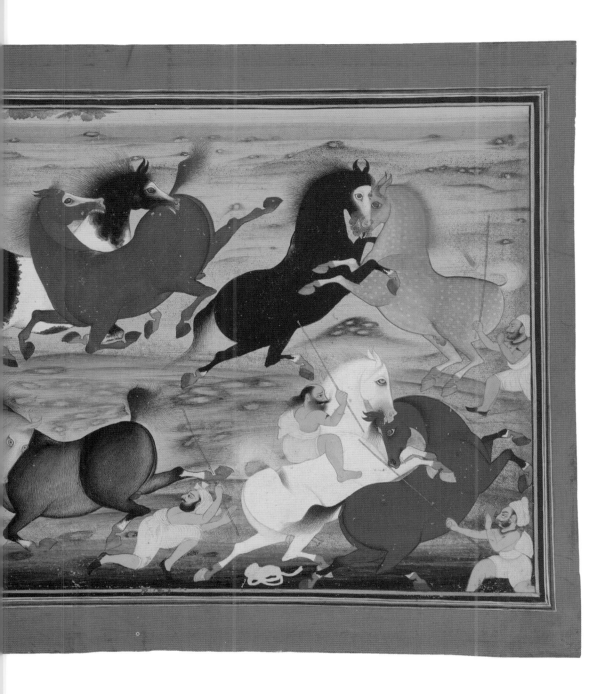

JOSEPH MALLORD WILLIAM TURNER
(British, 1775–1851)
View of Kenilworth Castle, ca. 1830

Transparent and opaque watercolor on wove
paper, 11½ x 17⅞ in. (29.2 x 45.4 cm)

Gift of Osgood Hooker
1967.4

The formidable castle-fortress of Kenilworth in Warwickshire was considered too great a threat by Oliver Cromwell in the 17th-century civil war and was partially dismantled by his troops. However, enough of the red sandstone castle remained to convey an impression of how grand it originally was, and it was immortalized and romanticized by Sir Walter Scott in his 1821 novel *Kenilworth*. In this watercolor Turner, perhaps the most famous English Romantic landscape and marine painter, has bathed the imposing ruin in dramatic, glowing light. Known as "the painter of light," Turner recorded the effects of sunlight on landscape in hundreds of his works. An engraving after this work was published in 1832 for Charles Heath's *Picturesque Views in England and Wales*. Previously owned by John Ruskin, the Victorian art critic, this is one of the most beautiful of the sheets painted for this publication and helped establish Turner as the greatest topographer of the Romantic era.

FERDINAND-VICTOR-EUGÈNE DELACROIX
(French, 1798–1863)
Arabs and Horses near Tangiers, ca. 1832

Transparent and opaque watercolor and graphite on wove
paper, 6⁹⁄₁₆ x 10⁷⁄₁₆ in. (16.7 x 26.5 cm)

Museum purchase, Mildred Anna Williams Collection
1951.35

Delacroix traveled to Morocco in 1832 with his patron, the comte de Morny. In a
series of sketchbooks and a diary he recorded the sights and sensations of this exotic
region, which would influence and inspire him for the remainder of his career. The
dignity of the people and the classical simplicity of their attire and attitude entranced
Delacroix. Many of his later works were based on his sketches of Moroccan life and
incorporated the animals he had seen. This watercolor is a carefully finished work,
which undoubtedly was painted after his trip using sketches and color notes he had
made on the spot. It is one of a group of 18 signed watercolors that Delacroix made
for the count to commemorate their trip.

UTAGAWA HIROSHIGE

(Japanese, 1797–1858)
Night Rain on the Karasaki Pine (Karasaki no yau),
from the series *Eight Views of Omi Province*
(Omi hakkei), ca. 1833–1835

Color woodcut, 8⅞ x 13¾ in. (22.6 x 34.9 cm)

Carlotta Mabury Collection
1964.141.28

Japanese painter and printmaker Hiroshige was known especially for his landscape prints, which fostered a new and far-reaching appreciation for nature in art. One of the dominant figures of the *ukiyo-e*, or popular, school of printmaking in the first half of the 19th century, he transformed everyday landscapes into intimate, poetic scenes that captured the ordinary person's experience of nature, as well as the varied moods of memorable places at different times. He is particularly known for his scenes featuring snow and rain, which have earned him the title of "the artist of rain, snow, and mist." His work not only altered the Japanese conception of landscape but also gained popularity in the West during the late 19th century, influencing artists such as Whistler, Cézanne, van Gogh, and Gauguin.

JULIA MARGARET CAMERON
(English, 1815–1879)
Sir John F. W. Herschel, 1867

Carbon print, 11¹⁵⁄₁₆ x 9⅛ in.
(30.3 x 23.1 cm)

Museum purchase,
Mrs. Milton S. Latham Fund
1993.23

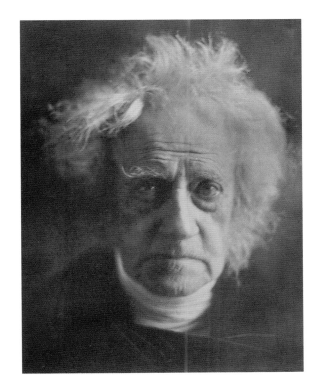

Julia Margaret Cameron was born in Calcutta and educated in France, and then returned to India. In 1848 she and her husband moved to England where Cameron made the acquaintance of and photographed a number of the prominent members of Victorian society. Sir John F. W. Herschel (1792–1871) was a distinguished astronomer, mathematician, and scientist, but to Cameron he was "a Teacher and High Priest," an "illustrious and revered as well as beloved friend," whom she had known for 30 years. In her direct, informal portrait of the scientist, considered the equal of Sir Isaac Newton, she made use of carefully directed light, soft focus, and a long exposure (counted in minutes rather than seconds). Furthermore, she had him tousle his hair to catch the light, draped him in black, and avoided the conventional scientific tomes, technical apparatus, and academic poses typically used to portray eminent individuals. In this manner she hoped to record "the greatness of the inner as well as the features of the outer man."

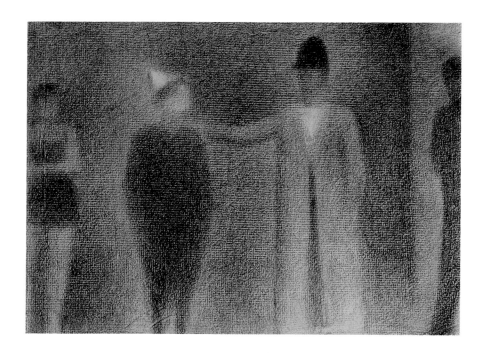

GEORGES SEURAT
(French, 1859–1891)
Study for *La parade de cirque*, 1886–1887

Black crayon on laid paper, 9⁹⁄₁₆ x 12⅛ in. (23.3 x 30.8 cm)

Museum purchase, Archer M. Huntington Fund
1947.1

Georges Seurat's drawings stand on their own among the significant artistic achievements of the late 19th century. His friend the artist Paul Signac called them "the most beautiful painter's drawings that ever existed." Like many other Parisian artists and poets of his time, Seurat was attracted to street fairs, circuses, *café-concerts,* and other forms of urban entertainment. This haunting work is one from a series of similar studies that Seurat made for the painting *La parade de cirque* (1888, Metropolitan Museum of Art, New York), showing the free entertainment presented at the entrance of a circus to entice customers. Whereas Seurat's other studies for this work focus on figures on a stage with a crowd in the foreground, here the artist reduced his depiction of clowns to a flat composition with only the barest essentials, concentrating instead on abstract tonality and the interplay of structure. In developing this new way of drawing, Seurat had an influence on the modern movements of 20th-century art.

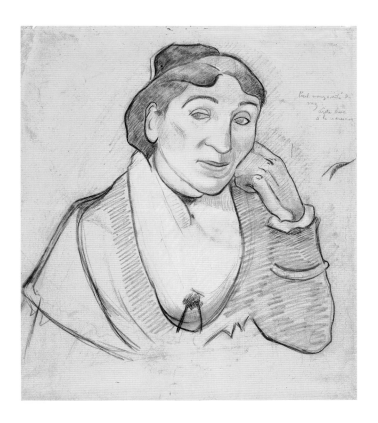

PAUL GAUGUIN
(French, 1848–1903)
L'arlésienne, Mme. Ginoux,
1888

Colored chalks and charcoal
with white chalk on wove paper
22¹⁄₁₆ x 19⅜ in. (56.1 x 49.2 cm)

Memorial gift from Dr. T. Edward
and Tullah Hanley, Bradford,
Pennsylvania
69.30.78

This monumental drawing and the paintings by
Gauguin and Vincent van Gogh that were inspired by
it are reminders of the intense, yet brief, interplay that
occurred between these two artistic giants. Gauguin
made this charcoal drawing during his stay at Arles in
the fall of 1888. Impressed by van Gogh's recently
completed painting *The Night Cafe* (Yale University
Art Gallery, New Haven), Gauguin painted his own
version of the scene (Pushkin Museum, Moscow),
with the looming figure of a woman dominating the
foreground. Madame Ginoux, wife of the owner of
the cafe, posed for this drawing, which served as a
preparatory study for Gauguin's painting. In this
sculptural drawing he employed the artistic concepts
that were emerging in his work: reduction of forms to
their essential outlines, avoidance of shadows, flatten-
ing of planes, and simplification of modeling.

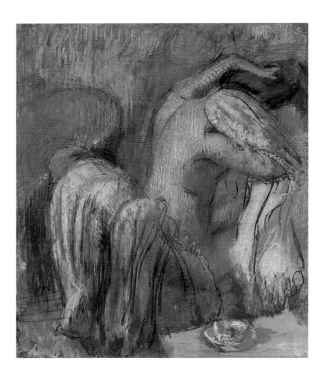

EDGAR DEGAS
(French, 1834–1917)
Femme s'essuyant (Seated Bather Drying Her Neck),
ca. 1890–1900

Pastel on two sheets of paper mounted on board, 27 x 22⅞ in. (68.7 x 58.1 cm)

Gift of Mrs. John Jay Ide
1995.62

From the mid-1870s Degas began to work increasingly in pastels, and it soon became his preferred medium, allowing for more direct and immediate results. As he stated, pastels were suitable for his delicate studies. He used vibrant colors in his pastel drawings and gave great attention to surface patterning, portraying bathers, milliners, laundresses, and groups of dancers against sketchily indicated backgrounds. For the poses, he depended on memory of earlier drawings, depicting expressive, meaningful gestures rather than precise lines and careful detailing. This work is an acknowledged masterpiece of Degas's late period. It reveals the astonishing vigor, complexity, and richness of his pastels, and its aggressive use of color and abstracted forms anticipates many aspects of modern art. While the work shows a nude seen from the side drying her neck, similar to other Degas compositions, it differs from many of his other studies in its highly saturated colors, especially the startling yellow and bright orange background.

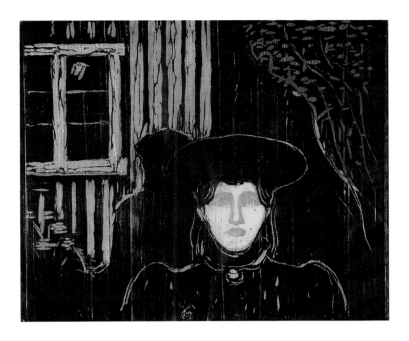

EDVARD MUNCH
(Norwegian, 1863–1944)
Mondschein I (Moonlight I), 1896

Color woodcut on thin Japanese paper, Sch. 81A, W. 90iv/iv
15¾ x 18½ in. (40 x 47 cm)

Museum purchase, Herman Michels Collection,
Vera Michels Bequest Fund
1993.121

Norwegian artist Edvard Munch, renowned for his psychologically charged paintings and prints, has long been recognized as one of the great modern artists and a leader of the Expressionist movement. His works are passionately emotional, depicting real and imaginary scenes of turbulence and anguish, often relating to illness and death, which he recalled from his childhood. His images of dread, anxiety, loneliness, death, and sexuality have become icons. In 1896 he began to work in woodcut, a printing method that relatively few artists adopted at that time. He was undoubtedly influenced by the work in this medium by Vallotton and Gauguin and must have been aware of Japanese woodcuts. In 1893 Munch painted an eerie image of a woman bathed in moonlight standing rigidly before a house. Three years later he made this woodcut, reducing the composition to the tree at right, the woman in close up, and the house.

PABLO PICASSO
(Spanish, 1881–1973)
Saint Matorel by Max Jacob
(Paris: Henry Kahnweiler, 1911), 1911

Book with 4 etchings on van Gelder Holland laid paper,
10½ x 7⅞ in. (26.7 x 20 cm)
Image shown: *Madamoiselle Léonie dans une chaise
longue*, 7¹³⁄₁₆ x 5⁹⁄₁₆ in. (19.8 x 14.2 cm)

The Reva and David Logan Collection of Illustrated Books,
gift of the Reva and David Logan Foundation
2000.200.59.1–4

Picasso spent the summer of 1910 in Cadaqués, Spain, where he made a series of
etchings to illustrate the burlesque tale *Saint Matorel* by Max Jacob, one of his earliest
and closest friends in Paris. Four prints, some of Picasso's first Cubist illustrations, were
ultimately chosen for the book. Jacob described the protagonist, his alter ego Victor
Matorel, as "a sort of Hamlet who dies in a monastery in a state of divine grace."
In reality, he based Matorel on his own life of extreme poverty and his monotonous
struggle of taking menial jobs to survive. The prosaic episodes in Matorel's life
interested Picasso, as well as the character of Mademoiselle Léonie, Matorel's great
love, who is depicted in two of his four etchings. The illustrations in this book are
considered among Picasso's greatest Cubist prints, created during a formative stage
in his career.

FERNAND LÉGER

(French, 1881–1955)

La fin du monde, filmée par l'ange N.-D. by Blaise Cendrars (Paris: Editions de la Sirène, 1919), 1919

Book with 22 *pochoirs*, 6 with line-block reproductions of ink drawings, in color on ivory wove Lafuma paper (except wrapper), 12⅝ x 9¹⁵⁄₁₆ x ⅝ in. (32.1 x 25.3 x .8 cm)

The Reva and David Logan Collection of Illustrated Books, gift of the Reva and David Logan Foundation
1998.40.77.1–22

La fin du monde was the most beautiful and accessible French artist's book of its era, selling for only 20 francs. The text of the novel, originally conceived as a screenplay by the witty and subversive poet Blaise Cendrars, is interrupted and defined by the bold lettering—both handwritten and stenciled—and the simple power of Léger's illustrations. In this book Léger, who utilized Cubism to portray the marvels of modern industrial life, combined dynamic, colliding images and brightly colored letters and numerals to create a sense of the moving images of film as the pages are turned. He often made use of photomechanical reproductions, which allowed his works to be printed in large editions. The strong primary colors were achieved by directly applying watercolor through the *pochoir* method, a process that makes use of hand stenciling.

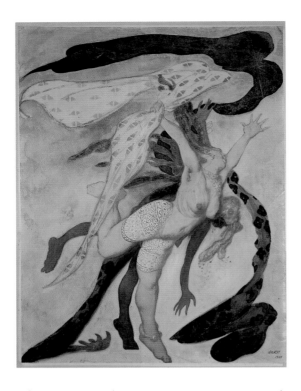

LÉON BAKST (Lev Samoilovich Rosenberg)
(Russian, 1866–1924)
Costume design for a dancer and slave, 1921

Graphite and watercolor on laid paper, 24½ x 18½ in. (62.2 x 47 cm)

Theater and Dance Collection, gift of Mrs. Adolph B. Spreckels
T&D1962.40

This is one of several drawings by Léon Bakst in the Fine Arts Museums'
rich and varied Theater and Dance Collection established by Alma de
Bretteville Spreckels, the founder of the Legion of Honor. Bakst based this
fully finished study of a seductive dancer on one of his original designs for
the ballet *Cléopâtre*, produced by the impresario Sergei Diaghilev at the
Théâtre du Châtelet, Paris, in 1909. Diaghilev was a principal contributor
to the cultural awakening that occurred in Russia in the early years of the
20th century. Bakst, a brilliant colorist, was one of the first artists commis-
sioned by Diaghilev to design dazzling costumes and sets for the Ballets
Russes. The sensuous beauty and vivid exoticism of Bakst's designs as well as
his view of the body as a kinetic construction captivated audiences.

WASSILY KANDINSKY
(French, born Russia, 1866–1944)
Untitled (Orange), 1923

Color lithograph, R. 180, 18⅞ x 17⅜ in. (47.8 x 44.2 cm)

Gift of Mrs. J. Wolf in memory of Miss Rachel Abel
1942.17

Russian-born artist Wassily Kandinsky is universally regarded as one of the pioneers of abstract art. From 1922 to 1933, when he taught at the Bauhaus, the pioneering German design and art school, he elaborated further on his geometric and, for the most part, wholly nonrepresentational compositions. He made works such as *Orange*, which continued his exploration of lithography, the technique that he recognized as the most modern print medium because of its malleability, ease of artistic execution, and ability to create large and uniform editions. Geometric elements took on increasing importance in both his teaching and his art. The circles in *Orange* represents Kandinsky's favorite pictorial motif during this period, which replaced the horseman from his earlier Blue Rider period, named for the group of Expressionist artists he cofounded.

A. M. CASSANDRE

(Adolphe Jean-Marie Mouron)
(French, 1901–1968)
Nord Express, 1927

Color lithograph poster,
41⅜ x 29½ in. (105 x 75 cm)

Museum purchase, Achenbach
Foundation for Graphic Arts
Endowment Fund
1989.1.66

The dynamic nature of 20th-century poster design at its best stood for elegance, modernism, and progress. During the Art Deco period, a time when the rapid expansion of travel by train, ship, bus, car, and aircraft was a phenomenon, speed and luxury were vital attributes to convey in advertising. The poster exemplifies this innovative form of marketing, promoting travel as a symbol of modernity and international sophistication. The artist Cassandre is considered to be one of 20th-century France's greatest and most influential poster designers, known for his bold, precise images. Although many of his memorable posters are figurative, they show the influence of modernist abstraction with their streamlined motifs of mechanization.

GIORGIO MORANDI
(Italian, 1890–1964)
Grande natura morta con la lampada a petrolio, 1930

Etching, V. 75, 14¼ x 12 in. (36.2 x 30.5 cm)

Museum purchase, Manug Terzian Bequest Fund
2002.136

Throughout his career, Morandi concentrated almost exclusively on landscapes and most famously on still lifes. With great sensitivity to tone, color, and compositional balance, he rearranged the same familiar bottles, boxes, lamps, and vases over and over again in search of subtle variations and formal possibilities. He is renowned for his virtuoso etching, printing nearly 140 works on a small press at home or at the Academy of Fine Arts in Bologna, where he was a professor. The technique appealed to him for its intimacy and methodical craftsmanship, and his delicate images occupy an important place in modern graphic art. In this example, Morandi used the etching needle in his typically rigorous fashion, defining forms and tonalities by means of meticulous layers of hatched and crosshatched lines. In his repetitive motifs and economical use of color and texture, Morandi was an important forerunner of Minimalism.

Textiles

FRAGMENT, PROBABLY OF A TUNIC

Egyptian, Coptic period, 6th century

Wool, linen; tapestry weave, 9¾ x 8⅜ in. (24.8 x 21.3 cm)

Gift of Arthur Sachs
1952.25

In ancient Egypt most people wore white linen because flax, from which linen is made, was difficult to dye by the means available. Colored squares, circles, and bands woven into the linen garments in tapestry weave first appeared in late antiquity and the Byzantine period. Wool and occasionally costly imported silk, fibers receptive to dyes, provided the color and patterning. This Coptic pictorial square, probably from a tunic, gives an indication of the high quality and richness of color in textiles woven in Egypt during this time. Retaining their bright colors through the ages, these textiles demonstrate the skill of Coptic dyers and the durability of natural dyes. Here, pagan symbols derived from classical art are merged with Christian iconography. Four swimming *nereids*, mythological water nymphs popular in late Roman mosaics, ride on the backs of sea monsters surrounded by fish, one of the earliest Christian symbols. The central medallion encloses a hunter or warrior.

TAPESTRY

Rabbit-Hunting with Ferrets

Franco-Flemish, probably Tournai, 1460–1470

Wool, silk; tapestry weave, 10 ft. x 11 ft. 11 in. (3.05 m x 3.63 m)

Museum purchase, M. H. de Young Endowment Fund
39.4.1

Inventories show that tapestries depicting peasant life were once popular with the aristocracy, although the subject is not common among existing works. This tapestry tells the story of a rabbit hunt. In the lower left corner a peasant releases a ferret into a rabbit furrow amid a dense forest of oak, holly, and orange trees. Seven men helped by three women capture the escaping rabbits in waiting hands and nets and then dispatch them with a single blow. The dignity and seriousness of purpose the hunters otherwise show is diminished by the caricaturelike quality of their coarse features and the rough simplicity of their dress. Two other panels from the same series, showing other stages of the hunt, survive in the Burrell Collection in Glasgow and in the Musée du Louvre.

LACE COLLAR (*FICHU*)
French, ca. 1690–1720

Linen; needle lace (point de France)
11¹⁵⁄₁₆ x 61¹³⁄₁₆ in. (30.3 x 157 cm)

Gift of Mrs. D. L. Wemple
77.24.13

The intricate pattern of this densely packed, pictorial needle lace, composed of mirrored halves, shows two fashionably dressed men drinking wine beneath a canopy. They are surrounded by romanticized American Indians shooting arrows—a popular theme at the time when the New World was opening to exploration—as well as dancing rabbits, cupids, squirrels, several types of birds, plants, palm trees, and flowers, some in cornucopias and others in swags. This delicate work was created entirely with a needle and thread in a style often considered to epitomize the height of lace-making arts. It is much lighter stylistically than the heavy Baroque laces of the 17th century, but it lacks the mesh ground characteristic of 18th-century laces. It may be seen as an example of the transition between the Baroque and Rococo periods of lace-making.

CHASUBLE AND DALMATIC

French, probably Paris, ca. 1700–1710

Silk, metallic thread; cut velvet, embroidery

Museum purchase, Dorothy Spreckels Munn
Bequest Fund
2004.9.1.1–2

In 1789, at the time of the French Revolution, much of the sumptuous liturgical attire of the French clergy, who were closely allied with the aristocracy, was wantonly destroyed. These two vestments, perhaps created for the royal chapel at Versailles, are part of a rare set of nine pieces that miraculously survived intact. Made of red velvet and lavishly embroidered in gold and polychrome silk, this chasuble is one of two matching dalmatics created toward the end of Louis XIV's reign. They were preserved by a family who claim descent from the marquise de Rochelambert, a lady-in-waiting to Marie-Antoinette, and Henri-Evard, marquis de Dreux-Brézé, grand master of ceremonies at the court of Louis XVI. Stylistically, the splendor and artistry of the ensemble date to the first decade of the 18th century, when the ponderous grandeur of Louis XIV and the French Baroque was giving way to the lighter, more graceful impulses that would later evolve into the Rococo style.

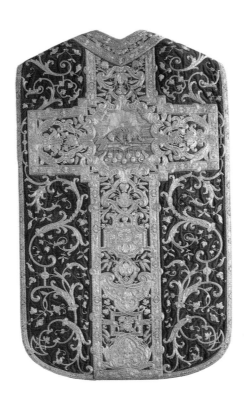

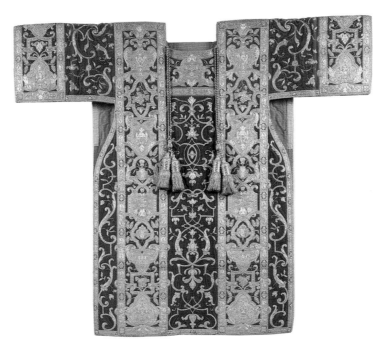

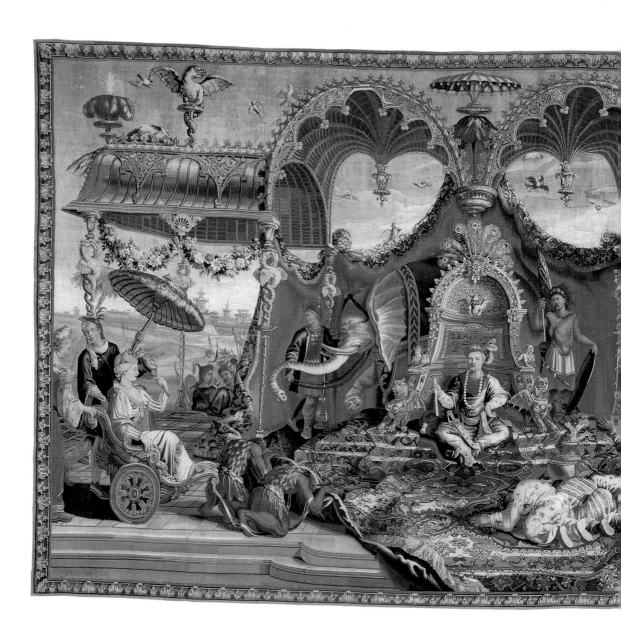

TAPESTRY

The Audience of the Emperor
From *The Story of the Emperor of China*
tapestry series
French, Beauvais, 1722–1723
Designed by Guy Louis de Vernansal,
Belin de Fontenay, and probably
Jean-Baptiste Monnoyer
Probably woven under the direction
of Mérou

Wool, silk; tapestry weave
10 ft. 5 in. x 16 ft. 6 in.
(3.18 m x 5.03 m)

Gift of the Roscoe and Margaret Oakes
Foundation
59.49.1

This fanciful tapestry is a wonderful example of the 18th-century craze for chinoiserie, European goods depicting Chinese themes and motifs. The feverish collecting of Oriental and Orient-inspired objects was spurred by contemporary illustrated accounts of Cathay. This particular scene was probably based on a description of a 17th-century Jesuit mission to the Manchu emperor's court. The exotically dressed emperor presides in the open air on a rich Oriental rug draped over a raised dais. He sits before a mosaic-lined niche topped by peacock feathers and decorated with griffins, sphinxes, and invented inscriptions. To the right, four visitors kowtow to him; to the left, a European woman sits in a Baroque rickshaw drawn by two black men. The arched loggia bedecked with garlands, feathers, and griffins, the elephant emerging from the back of the dais, and the whimsical costumes contribute to the tapestry's exotic air.

ALTAR FRONTAL

Italian, probably Naples, ca. 1725–1730

Linen, silk, metallic thread; embroidery, 38¾ x 82¾ in.
(98.4 x 210.2 cm)

Museum purchase, C. Barry Randall Bequest Fund
78.46

This needlework masterpiece, still magnificent nearly three centuries after it was made, was intended as an opulent altar frontal. Its allover embroidery, in several types of gold and silver metallic threads and polychrome silk, is characteristic of the unrivaled splendor of works of art made for Roman Catholic churches during the Baroque period. The dazzling, ornate interiors of these churches were designed with lavish displays of wealth to counter the inroads made by the severe style of the Reformation. Altar frontals were often embroidered almost entirely with gold and silver in elegant patterns. In this example, symmetrical floral arrangements set in padded, raised gold vases create a decorative pictorial design on a laid silver ground.

MASK FAN

English, for the Spanish market,
1740–1750

Opaque watercolor on vellum; ivory sticks
L. 11 in. (27.9 cm)

Gift of Susanne King Morrison in memory of
Elizabeth Brant King
1980.66

During the 18th century there was a fan for every social occasion. The mask
fan, with its cutout eyes, was an accessory that lent a woman mystery by allow-
ing her to conceal her face while spying undetected. There are only six mask
fans known in public and private collections; all feature a similar central oval
mask but have differing side scenes. Here, couples amuse themselves in town
and country. The townscape on the left, showing a woman in her sedan chair,
also appears on a fan now in the Kremlin. The remaining scenes are set in the
open countryside. Two couples picnic and hold hands while two ladies and a
man on a quiet river punt past a distant spire.

WOMAN'S SACK-BACK GOWN (*ROBE Á LA FRANÇAISE*)

French, ca. 1765

Silk satin brocade trimmed with silk fly fringe; lined with undyed linen and silk

Gift of Mrs. Chauncey Olcutt
55018

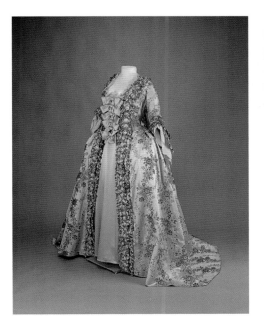 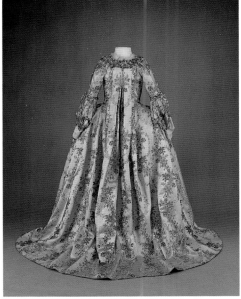

The voluminous sack-back gown evolved from the mantua type of casual dress that was introduced in the late 17th century by the ladies of Louis XIV's court in reaction to the king's edicts mandating rigidly structured court costume that was stiff and uncomfortable. Over time, the mantua was gradually tucked and folded closer to the body, finally resulting in this style of open gown, worn over a chemise, a corset, side hoops or panniers, and petticoats. The fullness at the back is a reminder of the loose, informal robe from which this style developed. Considerable assistance was required to put on a sack-back gown, for not only are the layers numerous but the wearer had to be tied, pinned, and sewn into the garment each time she wore it. The flowing sack-back gown was flattering to most women, and it was worn on a wide range of occasions until the 1770s, when it began to disappear. The floral pattern on this dress is characteristic of French textile designs of the period.

EDWARD BURNE-JONES

(English, 1833–1898)

WILLIAM MORRIS

(English, 1834–1896)

JOHN HENRY DEARLE

(English, 1860–1932)

Flora and *Pomona*, designed
1883–1885, woven 1920

Wool, silk, cotton; tapestry weave
Flora, 69⁵⁄₁₆ x 40³⁄₁₆ in.
(176 x 102 cm)
Pomoma, 70⅞ x 39⅜ in.
(180 x 100 cm)

Museum purchase, Dorothy Spreckels
Munn Bequest Fund
2001.120.1–2

This pair of tapestries was designed by Edward Burne-Jones and William Morris and woven at the Morris & Co. tapestry works at Merton Abbey, just outside London. William Morris, whose influence lives on in today's interiors and architecture, was a leader of the Arts and Crafts movement. Morris & Co. created an impressive array of objects, including furniture, stained glass, tableware, wallpaper, and books, but was most strongly associated with textiles, where Morris's love of medieval art, sense of color and texture, and understanding of pattern could be exercised to the fullest. Burne-Jones was a prolific painter and one of the foremost artists of the Aesthetic movement. He designed *Flora* and *Pomona,* his first foray into tapestry design, in collaboration with Morris. The subjects, Flora, the goddess of flowers and springtime, and Pomona, the goddess of fruit trees, gardens, and orchards, demonstrate Burne-Jones's characteristic fondness for portraying gods, goddesses, and ancient legends. Morris's assistant J. H. Dearle designed the millefleurs background.

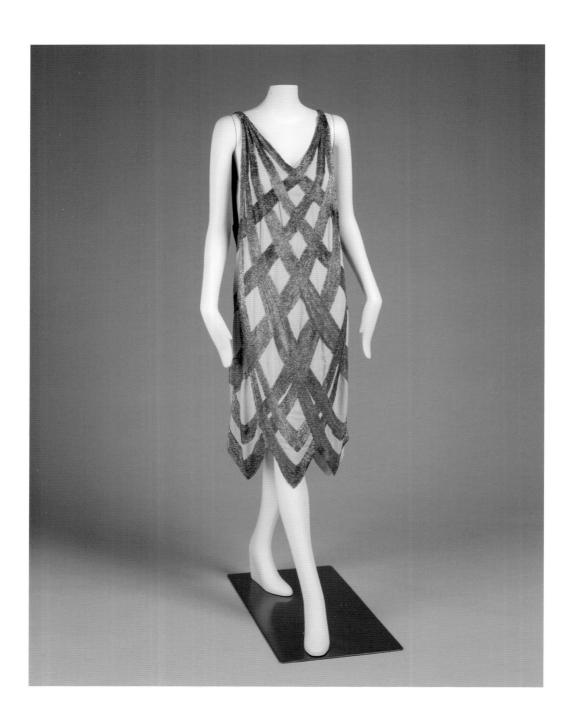

MADELEINE VIONNET
(French, 1876–1975)
Evening dress, ca. 1922

Silk crepe with opalescent glass
bead embroidery

Museum purchase, gift of
Mr. and Mrs. Alfred S. Wilsey
2001.65a–b

Madeleine Vionnet changed the course of fashion design by inventing the bias cut, among other ingenious techniques, and produced timeless clothing that is considered some of the most beautiful ever conceived. During the period between the two world wars, this highly regarded designer collaborated with the Italian Futurist artist Ernesto Thayaht, whom she had met in Italy. The involvement of Thayaht in the creation of this dress is supported by drawings of a similar, though not identical, costume in the artist's family archives. Vionnet's spiraling beadwork, which seems to wrap around the body, incorporates the concept of movement as dynamic energy, an important tenet of the Futurist manifesto: "Everything moves, everything runs, everything turns swiftly. The figure in front of us never is still, but ceaselessly appears and disappears."

Published in association with Scala Publishers, London,
by the Fine Arts Museums of San Francisco:
Ann Heath Karlstrom, Director of Publications
and Graphic Design
Elisa Urbanelli, Managing Editor

Text and Photography Copyright © 2007 Fine Arts Museums
of San Francisco
This edition Copyright © 2007 Scala Publishers Limited

British Library Cataloging in Publication Data. A catalogue
record for this book is available from the British Library.

Library of Congress Control Number: 2007930168

First published in 2007 by
Scala Publishers Limited
Northburgh House
10 Northburgh Street
London EC1V 0AT
United Kingdom

Distributed outside of the Fine Arts Museums of San
Francisco in the North American book trade by
Antique Collectors' Club Limited
Eastworks
116 Pleasant Street, Suite #60B
Easthampton, MA 01027
United States of America

ISBN: 978-1-85759-407-2

Designed by Pooja Bakri

Printed in Singapore

10 9 8 7 6 5 4 3 2 1

Wassily Kandinsky, *Untitled (Orange)*, 1923 © 2007
Artists Rights Society (ARS), New York/ADAGP, Paris

Fernand Léger, *La fin du monde, filmée par l'ange N.-D.*,
1919 © 2007 Artists Rights Society (ARS), New
York/ADAGP, Paris

Aristide-Joseph-Bonaventure Maillol, *Torso of l'Ile de
France*, 1921 © 2007 Artists Rights Society (ARS),
New York/ADAGP, Paris

Pablo Picasso, *Saint Matorel*, 1911 © 2007 Estate of
Pablo Picasso/Artists Rights Society (ARS), New York

Pablo Picasso, *Still Life with Skull, Leeks, and Pitcher*,
1945 © 2007 Estate of Pablo Picasso/Artists Rights
Society (ARS), New York

Cover: Giovanni Battista Tiepolo, *The Empire of Flora*
[detail], ca. 1743 (see pages 98–99)

Page 2: *Rabbit-Hunting with Ferrets* [detail], Franco-
Flemish, 1460–1470 (see page 146)

Page 4: Enea Vico, *The Studio of Baccio Bandinelli, after
Baccio Bandinelli* [detail], ca. 1546 (see page 122)

Page 14: Plaque from Nimrud [detail], Syro-Phoenician,
8th–7th century BC (see pages 26–27)

Page 44: Panel with a Vase of Flowers [detail], attributed
to Matteo Nigetti, 1600–1650 (see pages 48–49)

Page 62: Corneille van Clève, *Selene and Endymion*
[detail], ca. 1704 (see page 70)

Page 76: Mattia Preti, *St. John the Baptist Preaching*
[detail], ca. 1665 (see page 87)

Page 118: Wassily Kandinsky, *Untitled (Orange)* [detail],
1923 (see page 139)

Page 142: Edward Burne-Jones, William Morris, and John
Henry Dearle, *Flora* [detail], 1883–1885, woven 1920
(see pages 156–157)

High Performance SQL Server DBA
Tuning & Optimization Secrets

Robin Schumacher